London, England, April 1959. I saw where a man had arranged his artwork for sale, against a wall outside the National Gallery. His paintings were modest in scale and concept, with the usual subjects, but the sign he made proclaimed his authorship:

All my own work.

CHRISTOPHER PRATT

ALL MY OWN WORK

Josée Drouin-Brisebois
With an Introduction by Jeffrey Spalding

National Gallery of Canada, Ottawa
in association with
Douglas & McIntyre, Vancouver/Toronto

2005

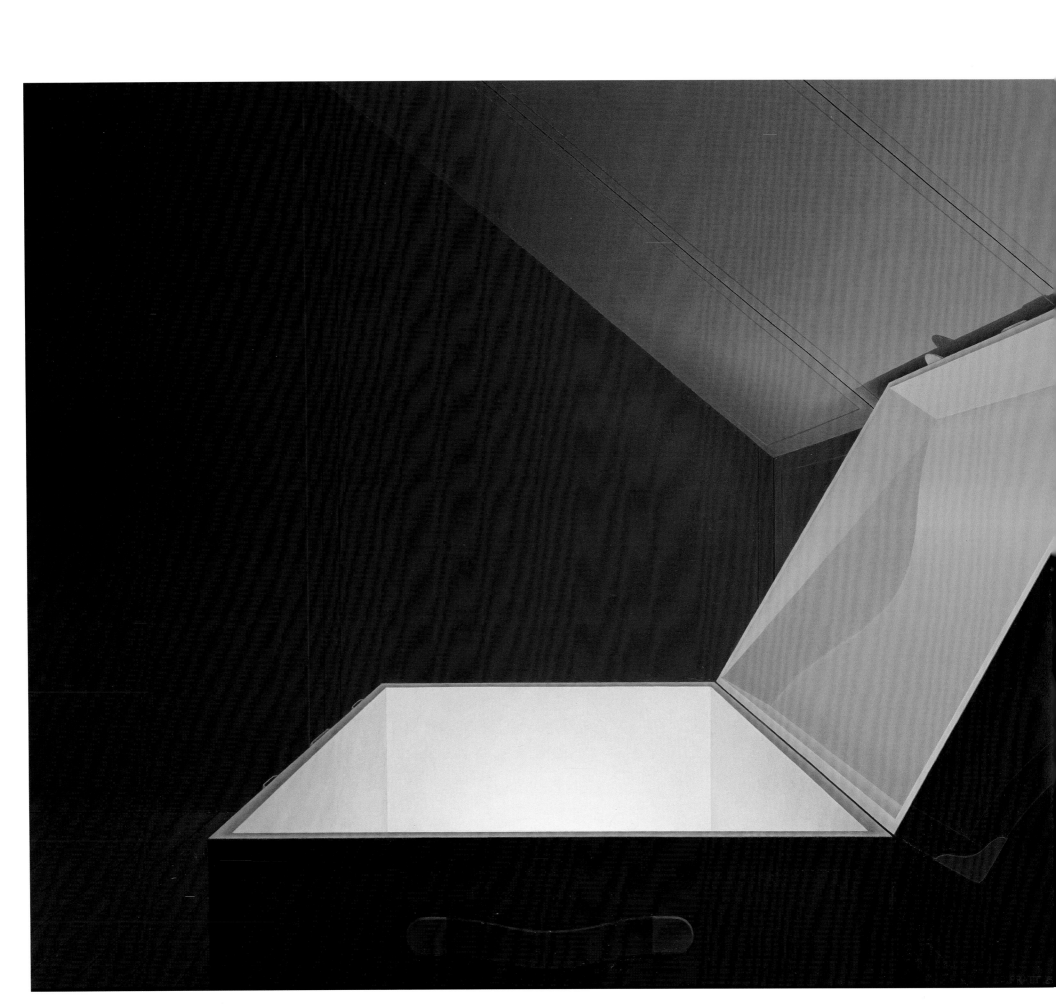

CONTENTS

MESSAGE FROM THE PATRON

I. David Marshall

Christopher Pratt is one of this country's foremost living artists, capturing the Canadian soul in his spare and spiritual paintings. I have been an admirer of Mr. Pratt for many years, and it gives me great pleasure to support this magnificent exhibition.

FOREWORD

Pierre Théberge, O.C., C.Q.
Director,
National Gallery of Canada, Ottawa

Many Canadian artists have created works that capture the unique qualities of the northern landscape and express deep attachment to their surroundings. Few have done this with such abiding passion and commitment as Christopher Pratt. The National Gallery of Canada is proud to mark the seventieth birthday of one of Canada's most celebrated painters with *Christopher Pratt*, a major exhibition representing his achievements over the last four decades.

Born in St. John's, Newfoundland, in 1935, Pratt has lived most of his life on the island and proudly asserts his East Coast origins. With an eye always to his environment, he has created some of the most memorable and cherished images in contemporary Canadian art. Paintings like *Whaling Station*, *Pedestrian Tunnel*, and *Military Presence* are rooted in the artist's personal experience of specific places, yet embody timeless, universal qualities that appeal to audiences everywhere.

The National Gallery has a longstanding and special relationship with Christopher Pratt. In 1961, the print *Boat in Sand* was selected for the gallery's *Fourth Biennial Exhibition* and was later acquired for the collection. Since then, the gallery has built important holdings of Pratt's paintings and prints, including the recent major work, *Deer Lake: Junction Brook Memorial*. In 2003, the National Gallery collaborated with the Canadiana Fund State Art Collection, Ottawa, to present and tour the exhibition of prints, *Christopher Pratt: Places I Have Been.*

Following on that exhibition, *Christopher Pratt* is unique in highlighting the artist's recent production and focusing on his paintings; some sixty canvases produced between 1964 and 2004 are featured, with an emphasis on work from the last twenty years. Study drawings for seven major paintings reveal the evolution of Pratt's images over the course of his creative process. Whether he depicts landscapes, seascapes, boats, buildings, or the female figure, over the last two decades Pratt's work has continued to evolve as the artist now takes a more direct approach, working less from memories of places and events, and more from his immediate experiences. He continues, however, with his lifelong search for order and simplicity, using art to distil the essence of his environment through his personal response to his surroundings. The images that result – tranquil, tense, and haunting at once – remain unmistakably his own.

Through this touring exhibition, Christopher Pratt's national reputation and international regard are justly enhanced. We are grateful to our sponsor, David Marshall, and to the private, public, and corporate lenders whose generosity has made this exhibition possible. I would like to thank the catalogue authors for their insightful contributions. Exhibition curator Josée Drouin-Brisebois offers a unique perspective by considering how Pratt's work incorporates the artist's political concerns. Jeffrey Spalding, Director of the Art Gallery of Nova Scotia, Halifax, gives a thought-provoking analysis of changes in the recent work of his long-time friend. These texts are complemented by an interview with the artist that Barbara Dytnerska, Education Officer at the National Gallery, conducted for the exhibition. I thank the gallery staff who have been involved in this important project. Finally, we are greatly indebted to Christopher Pratt for his invaluable collaboration. Just as he charted a new artistic course following his 1985 retrospective at the Vancouver Art Gallery, we look forward to where his reflections on this exhibition will lead him in the future.

ACKNOWLEDGEMENTS

Josée Drouin-Brisebois
Assistant Curator, Contemporary Art
National Gallery of Canada, Ottawa

Every exhibition is a collaborative effort, and many people have contributed to the success of this project. Foremost, I am grateful to National Gallery Director Pierre Théberge for giving me the opportunity to showcase Christopher Pratt's recent work. I have the privilege of working with a remarkable team at the gallery, one whose energy and expertise have helped not only to realize this exhibition, but to make it a joyous experience, as well. In thanking all of my colleagues, I would like to mention a few in particular. Kitty Scott, Curator, Contemporary Art, was always ready to provide insightful counsel. Jonathan Shaughnessy, Curatorial Assistant, helped to coordinate the project, and in their roles as curatorial interns, Michelle McGeough conducted brilliant research, while Leah Turner acted as an important support. Shirley Proulx provided ready administrative assistance. Among other invaluable contributors, I thank Daniel Amadei and Karen Colby-Stothart in Exhibitions, Julie Hodgson for her superior skill in managing the show, Danielle Allard for coordinating the tour, Stefan Canuel for his outstanding design of the exhibition space and graphic material, and the Technical Services team, led by Christine Feniak, for their expert installation. Barbara Dytnerska developed the exhibition's educational component, conducting a thoughtful interview of the artist for the catalogue and producing an audioguide and video with the assistance of technologist Marc-Antoine Morel. My thanks extend to Ceridwen Maycock, who coordinated shipping, to Geneviève Saulnier for her conservation work, to Mark Paradis and his Multimedia Services team, to Emily Tolot and Lisa Turcotte for overseeing special events, and to the National Gallery of Canada Foundation, which secured sponsorship for the exhibition.

The publication of this catalogue was an equally collaborate effort, as Chief of Publications Serge Thériault led a production team committed to excellence. To English text editor Marnie Butvin, French text editors Stéphanie Moreau and Danielle Martel, translators Julie Desgagné, Arlette Francière, and Traductions Larrass Translations, picture editor Andrea Fajrajsl, and publication coordinator Anne Tessier, I am grateful for their dedication and enthusiasm for detail. My sincere thanks go to Jeffrey Spalding, Director and Chief Curator of the Art Gallery of Nova Scotia, who enriched this book with his introduction, writing as both a scholar and a friend of the artist. I also acknowledge Réjean Myette and François Martin for their exceptional catalogue design, and Douglas & McIntyre for participating as copublishers.

Lenders are key to an exhibition of this nature. I express my deepest appreciation to the private and corporate collectors and the museums that loaned their treasured artworks. David Marshall was most gracious in not only lending paintings, but in sponsoring the show, as well. Mira Godard, Christopher Pratt's art dealer, was invaluable as both a lender and a source of information. The staff at her gallery, in particular Gisella Giacalone, provided support throughout the preparation of the exhibition. The artist's partner and assistant Jeanette Meehan, and his secretary Brenda Kielley showed much patience and professionalism as they conveyed information between Ottawa and Salmonier, Newfoundland.

Finally, I express my heartfelt appreciation to Christopher Pratt, who has been generous and enthusiastic about the project from its inception, and who graciously shared with me a part of his Newfoundland. Through this exhibition, we acknowledge and celebrate his distinct contribution to the arts and culture of his native province and all of Canada. It is my privilege to know him, and a pleasure to present his work at the National Gallery of Canada.

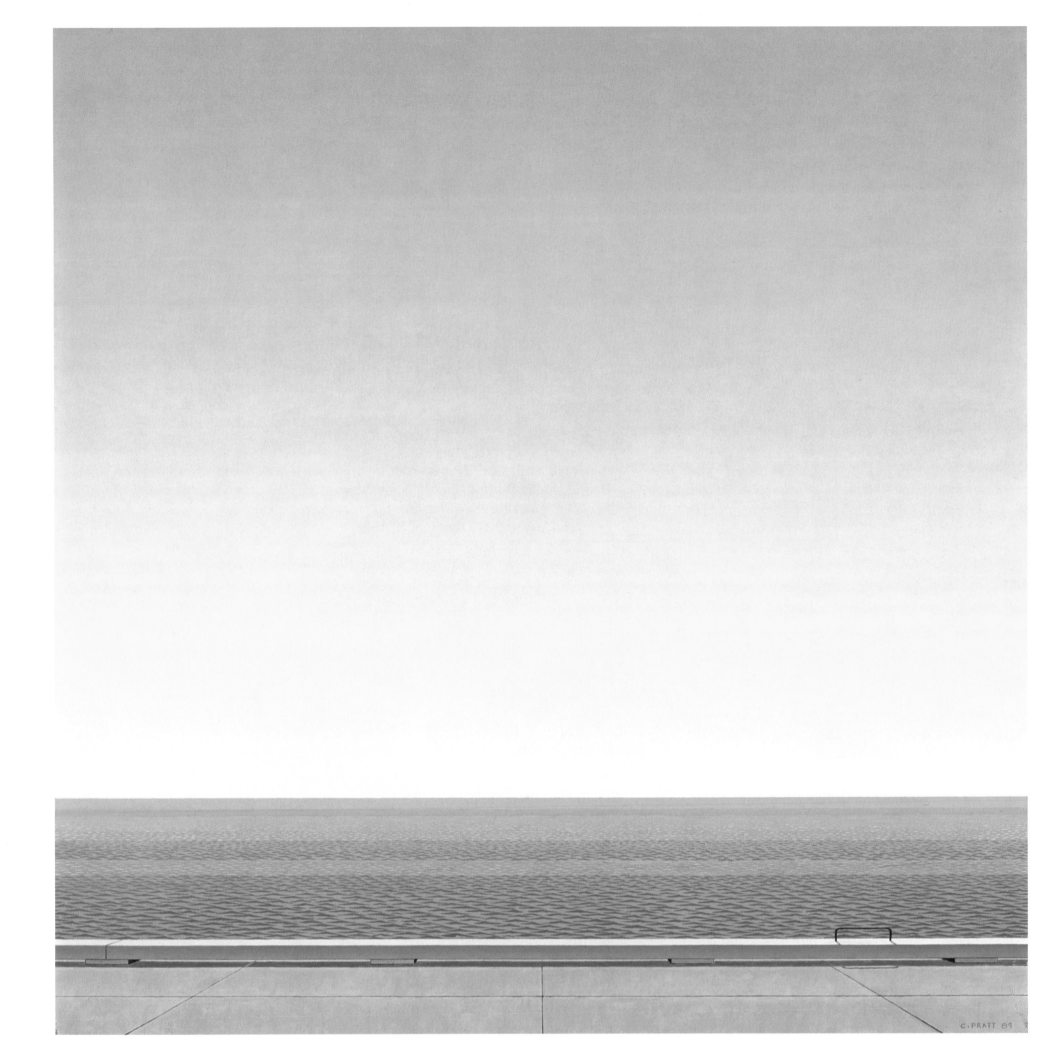

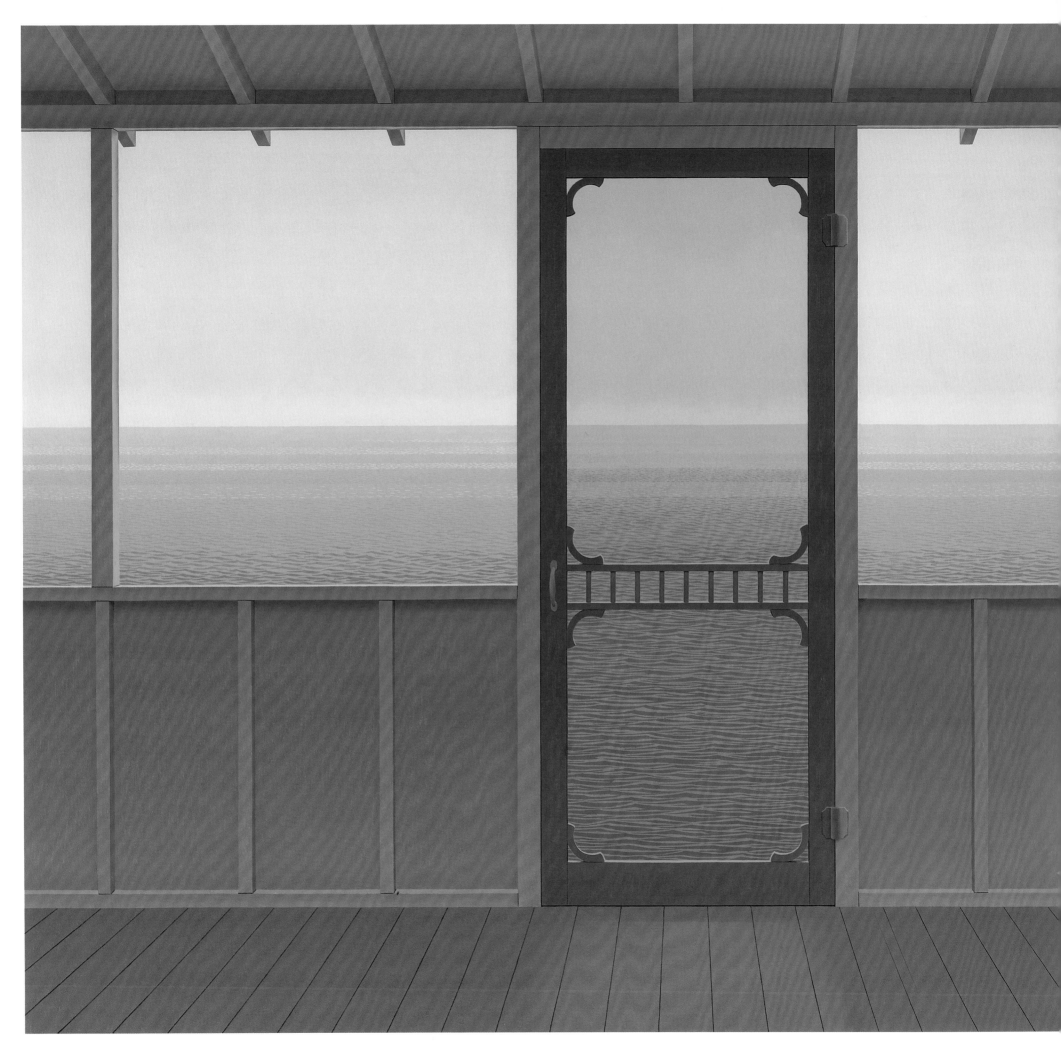

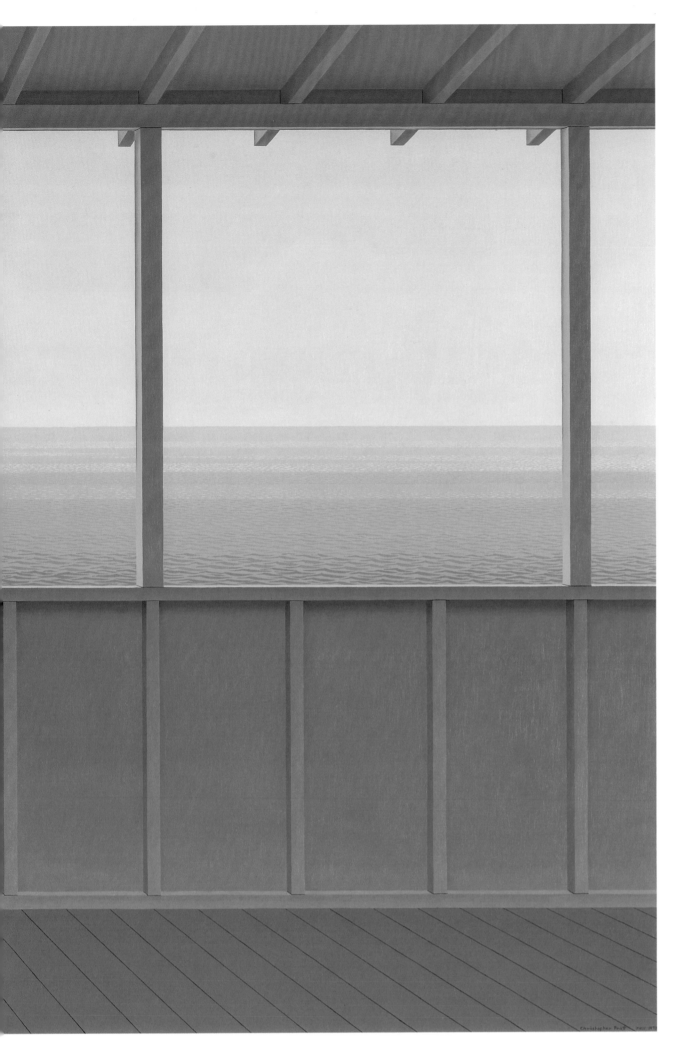

A BRIEF FORAY INTO THE WORLD OF CHRISTOPHER PRATT

Jeffrey Spalding

In my mind I often visit the places conjured by Christopher Pratt's pictures, contemplating their offered enigmas, drifting to introspective reverie. Repeat journeys are endlessly rewarding. I'm content to meet these memorable thought-pictures head on, as is. It never occurs to me to venture in my mind's eye through their depicted doorways, to lift the blinds, throw open the windows, or peek around the corners. I feel no need to confirm the indeterminate source of light that suffuses their space from somewhere just off-stage, out of sight. These pictures give me great satisfaction. I don't need them to evolve. They need not, on my behalf, proceed apace to the next chapter, to a new development. Their open-ended narratives invigorate my spirit and compel me to replay their elemental dramas. Encounters with paintings like *Shop on an Island* (1969, p. 51), *Station* (1972, p. 13), and *Cottage* (1973, pp. 10–11) remain as challenging and satisfying to me now as the first time I saw them. I marvel and muse: how is it that their subjects manage to flirt with, and yet skirt, sentimental representation?

Pratt came into prominence as an image painter, not a representational painter; this slight distinction associates his work with the traditions cherished by art museums. His early pictures delight equally in content and form; they are constructed realities that blend memory and dreams while acknowledging paint and colour as qualities to be enjoyed for their own sake. They knowingly engage in a dialogue about painting and its history, offering up the possibilities, limits, and pleasures of constructing an object that is emphatically two-dimensional and yet presents the illusion of recession into space and time. They effect philosophical complexity through physical simplicity: a search for order and higher purpose that has always signalled the spiritual in art.

Pratt's lean, spare work from the 1960s and 1970s was an influential precursor to the emergence of New Image painting in Canada; it left an indelible impression on a generation of artists in Canada, appearing at a time when art needed urgently to transform. The guiding verities of the recent past – Lawren S. Harris's "Art is the distillate of life" and Mies van der Rohe's "Less is more" – propelled art toward radical simplification and geometric abstraction. But by the mid-seventies, formal restraint was an albatross, a dead weight impeding progress. Pure abstraction had peaked, the notebooks had been raided, the cupboard was bare. Pratt instilled new promise, demonstrating that painters could once again conjure recognizable images without hitting the skids and colliding headlong into illustration. He defined a middle option in narrative representations retaining emblematic "thing-ness" that holds its own in the company of Yves Gaucher's geometric abstractions.

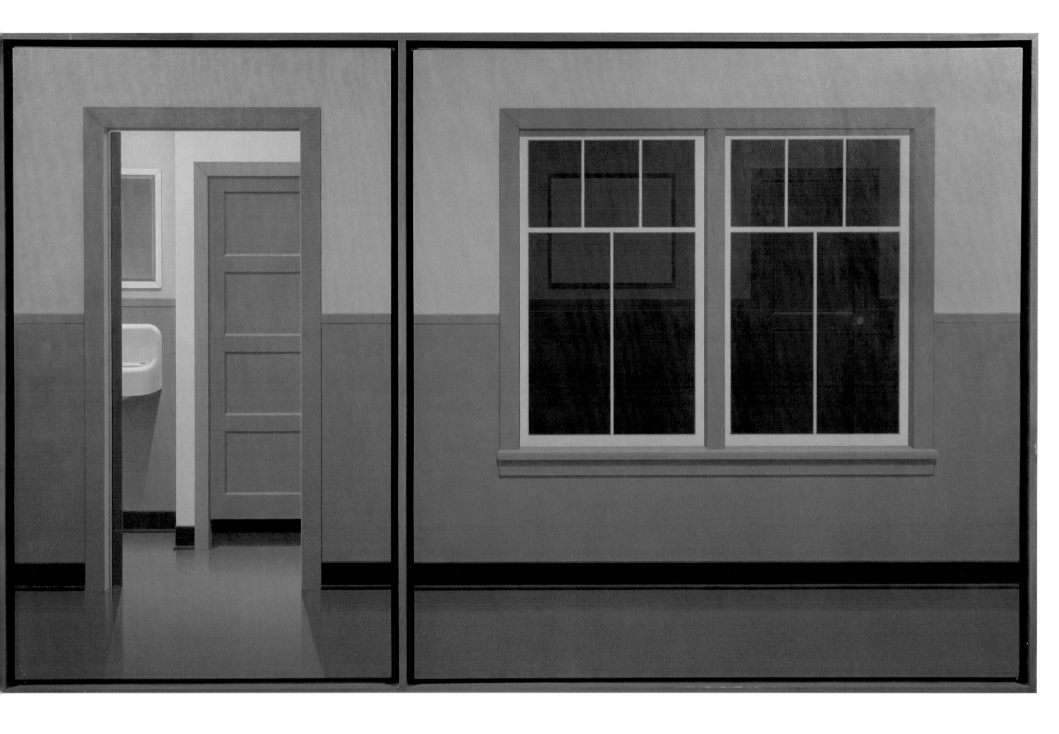

1
Christopher Pratt, *Christopher Pratt: Personal
Reflections on a Life in Art.* (Toronto: Key Porter,
1995): 147.

March Night (1976, pp. 14–15) and *Basement Flat* (1978, p. 17) formed a way station for late modernism, delighting in "the problems of painting." The clapboard wall in *March Night* acknowledges the properties of paint as material substance, as a layer covering a flat surface to create a "painted object." The clapboard patterns lie on the surface, with comparatively little blending or shading and without allusion to perspective or the third dimension; their compositional alignment conforms to the dictates of Frank Stella's "deductive structure." *March Night* is one of the most austere of Pratt's reductive architectural works, accepting the modern proscription except for one quirky transgression: off to the right, a dark grey rectangle gradually admits visual penetration; atmospheric perspective allows access to deep space, to infinity. In *Basement Flat*, most of the surfaces consist of flat, opaque paint, punctured by infinitesimal subtle gradations that coax our perceptions to read four rectangles as simulations of windows.

Whaling Station (1983, pp. 18–19) chills the heart with its allusion to tragic human failings; despite sparse visual clues, Pratt associates the "measured intervals" of the rigid bunks in whalers' sleeping quarters with "the calculations of the Holocaust."[1] The image was a long time in gestation: the initial drawings done in 1972 at the Hawke Harbour, Labrador, whaling station document the hardships and privations endured by men who lived in cramped, uncomfortable conditions. The final painting heightens our anxiety by offering up the unforgiving surfaces of the bunks in the pink tones of vulnerable flesh. In contrast to *March Night*, here Pratt reintroduces perspective and shading to accentuate the drama of the subject through the literal and figurative depth of the image.

In *March Night*, *Basement Flat*, and *Whaling Station*, the Mondrian of Newfoundland meets Rothko's abstract sublime. We use paintings like these to contemplate answers to life's grand mysteries. The calculated regularity of clapboard in *March Night* serves as a metaphor measuring our temporal stay on earth: we countenance them like the annual rings of trees or the rhythmic lap of waves on a shore. The wall measures the here and now. Off to the right we peer into the future, the infinite abyss of space. It is a solemn philosophic inquiry. While *March Night* engages the domain of the intellect where spirituality must be warranted through reason, *Whaling Station* rejects the concept that reason is capable of offering guidance or solace.

Pratt viewed his 1985 retrospective at the Vancouver Art Gallery as an occasion for mid-career stock-taking. His work to date walked a tightrope between representation and modernism; keeping the balance right was critical to its inclusion within a larger cultural discussion. As a booster, I would be only too delighted were Pratt to keep right on exploring variations of the same modernist spirit, but he had new stories to tell, causes to champion, passions to divulge. He imagined other adventures and set a conscious course to change. The artist made a clear declaration that it was time for him to switch tracks, to move on.

If we consider that "art is life seen through a temperament," then we might conclude from the evidence of the past two decades that Pratt has tempered his life view. In the immediate aftermath of the retrospective show, Pratt assessed that certain works might benefit from adjustments of scale or changes in medium. He set out to echo earlier subjects and stylistic treatment, responding to the youthful sentiments of his first artistic loves. Putting his accrued professional success on the line, he was determined to be the *agent provocateur* who would deconstruct his standing public persona. He was willing to risk it all in an attempt to rebirth the psychic space within which he could envisage his new art. As a result, while certain visual elements remain constant, others have changed in outward appearance. There is a palpable switch in attitude and pictorial body language. The veil has been lifted to divulge a different side of Pratt's personality: impulses and motives hitherto assiduously concealed.

Big Boat (1986–87, pp. 22–23) proclaims an operatic overture and the opening act of a nocturnal underwater fantasy played through a proscenium. House lights dimmed, curtains drawn, spotlight centre-stage, the vessel floats like a sleek phantom, a sea creature in suspended animation. Held up before our gaze, it waits to be enacted, to be launched. Its character is restrained rather than restraint; a fish out of water, we sense its passive resistance, capable of unleashing its latent power. It bides its time.

The hulls of vessels in *Big Boat*, *Big Cigarette* (1993, p. 21), and *Four White Boats: Canadian Gothic* (2002, p. 49) have allowed the master of the straightedge a legitimate outlet to embrace bulbous, curvilinear forms. Where Pratt's architectural subjects were often planar and two-dimensional, his boats flesh out their three-dimensionality. His attentions are not given to shipwrecked derelicts; instead he is taken with sleek and utterly sophisticated marvels of marine engineering. *Big Cigarette* is a muscle boat that has nothing to do with the dignity and decorum of sailing and yachting. Instead, it is flashy and vulgar, "hulking and belligerent," a demonstration of raw masculinity flaunting its prow-ess. Suspended beside barrels of fuel in a "clandestine and dangerous environment," it alludes, in Pratt's words, to how "entertainments frequently bridge the gap between the innocent and sinister, just as our private thoughts are often darker than the ones we voice."[2]

The Island (1989, p. 24) and *In the Heat of Summer* (1990, p. 25) are variations on the compositional format we know through *March Night*. Both attach a portico to the house and adopt a stylistic treatment akin to late Gothic art; *The Island* is a scene suitable for a Giotto annunciation. With the clapboard in both paintings plunged into shade, the capacity of the walls and closed doors to constrain or restrict our visual movement has been greatly reduced. The light draws us, inexorably, off to the right; bypassing the wall, we now rush with buoyant optimism into infinite space.

2
Pratt, 198.

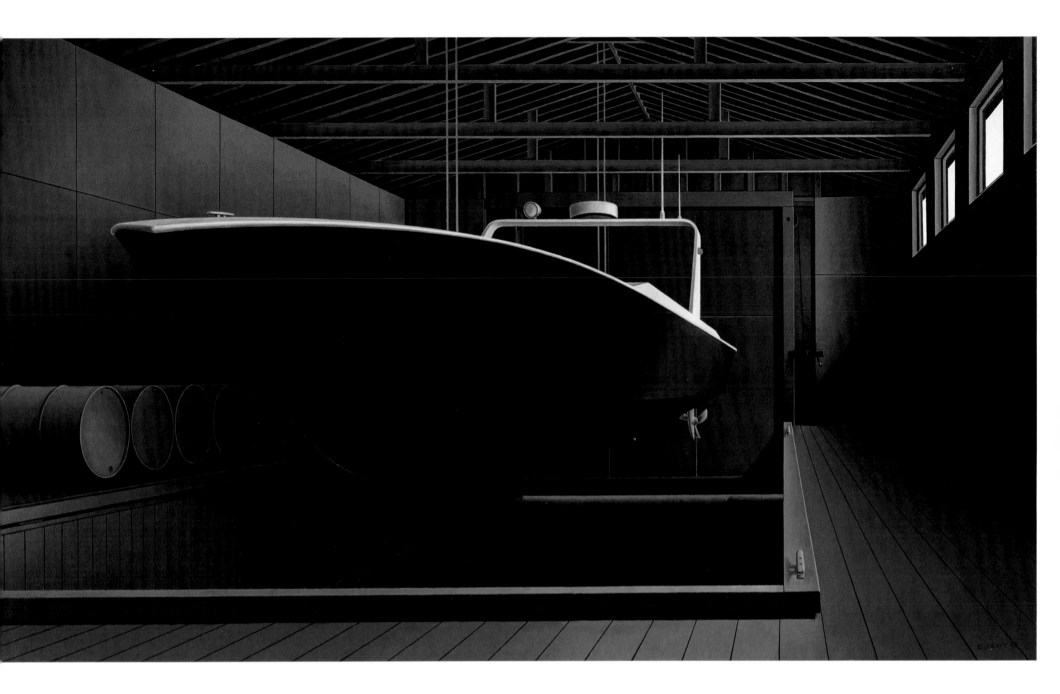

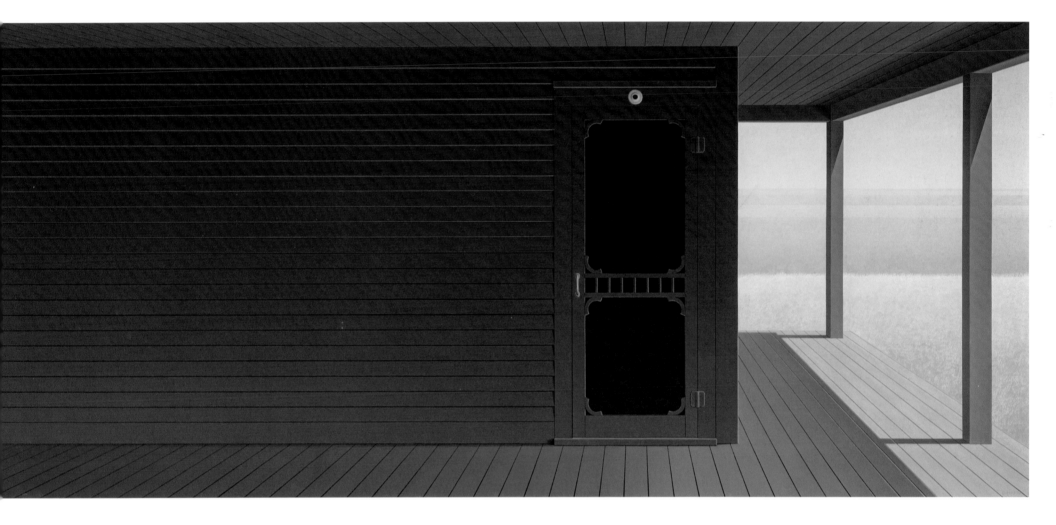

Fig. 1
Summer Interior, 1990.
Oil on board, 92 × 58.4 cm.
Collection of J. Rosenthal

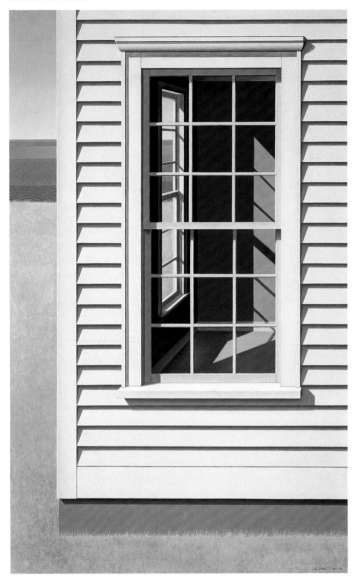

Fig. 2
Window by the Sea, 1963.
Graphite on paper, 30.5 × 19 cm.
The Rooms Corporation, Provincial Art Gallery
Division, St. John's, Memorial University of
Newfoundland Collection

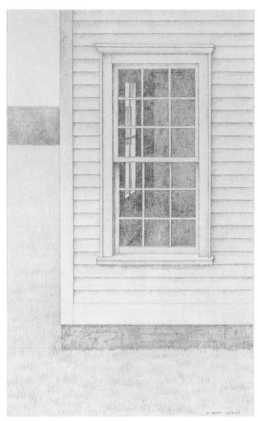

In *Summer Interior* (1990, fig. 1) Pratt turns a black and white 1963 drawing, *Window by the Sea* (fig. 2), into a painting, breathing in life through a primary triad of red, yellow, and blue, as rendered in pastel tints. With reference to the drawing, Pratt wrote: "It's easy to be anthropomorphic about windows; they lend human attributes to buildings: sight, dignity, mystery, transparency."[3] In contrast to the shadowy interior of the drawn house, however, the painting offers an inner glow as light penetrates the window and flashes a pink swatch on the wall. The farther window in the drawing features four panes, to create a cruciform grille. The painted window bears six panes, dispelling the sign of the cross and its attendant symbolism. There is new spring in the step.

The frontal alignment and rectilinear composition in the majority of Pratt pictures before 1985 inhibit the illusion of deep space. *Salt Shed Interior* (1988, p. 27) shatters this expectation as the pillars, beams, and floorboards boldly assert a linear perspective that propels the eye headlong into a blank, solid wall. Windows – once Pratt's ubiquitous emblem of potential visual exit – are offset and allow no release. It is a compelling, dreamlike image, this arresting mound of organic whiteness contained within an interior. Only a Canadian (né Newfoundlander) could desire more giant piles of white in his life, even in summer, even inside.

3
Pratt, 28.

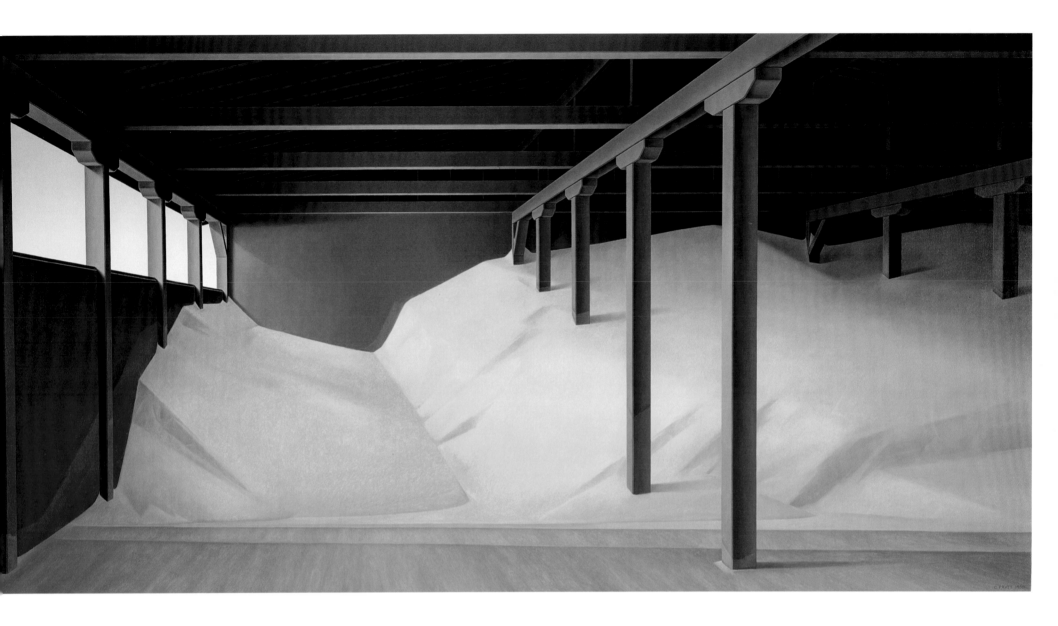

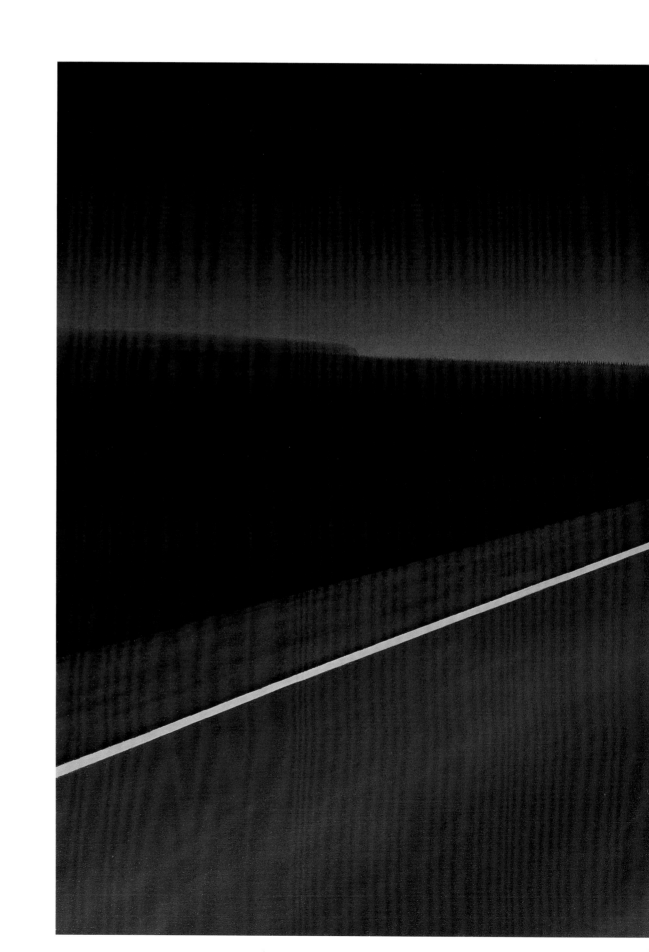

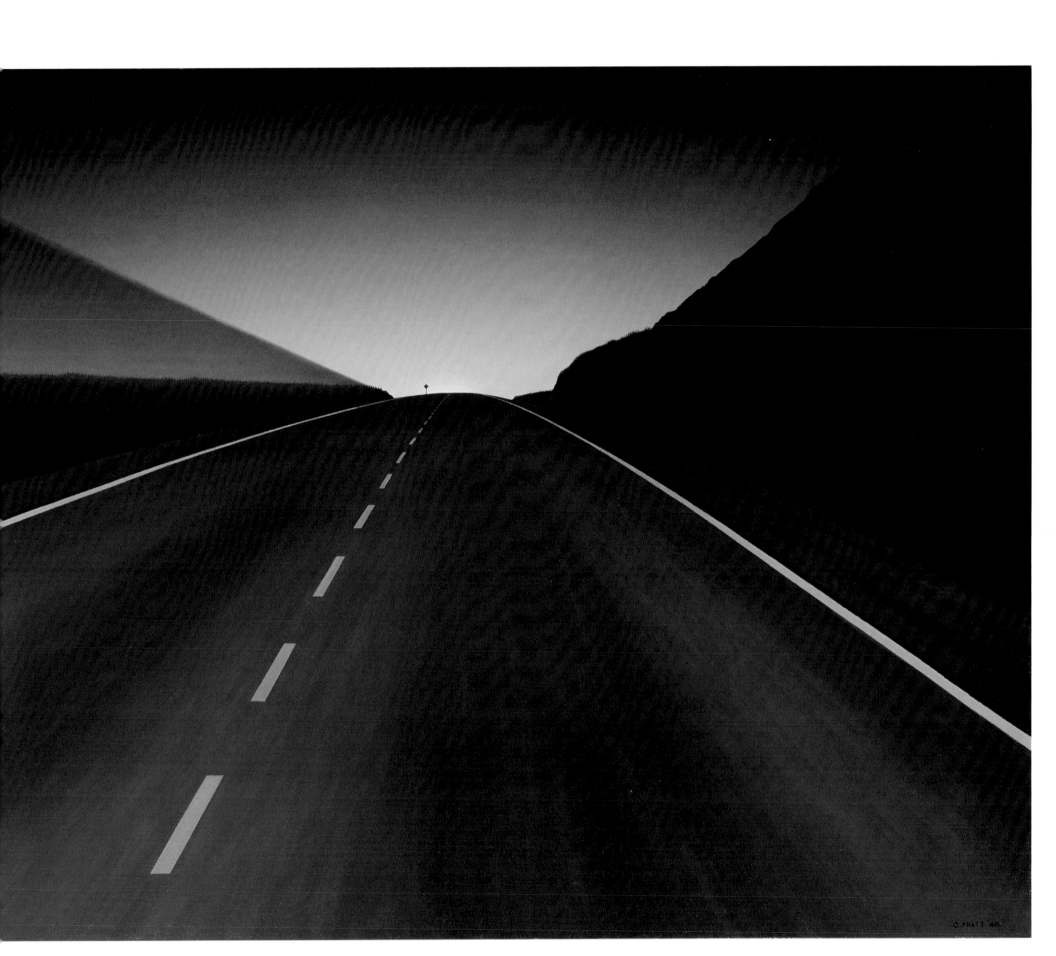

Night Road (1988, pp. 28–29) is a poetic pictorial account of a nocturnal experience familiar and exclusive to modern day people: the moment just before an oncoming vehicle crests the road and headlights blind our view. A triumphant departure from the straightedge, the picture abandons classical reserve to cry out for romantic release. Now that caution is abandoned, the artist's emotive side emerges. *Pedestrian Tunnel* (1991, p. 42) extends the curvilinear revolt, starting off slow before accelerating to magnetically pull us into a vortex of darkness, to surrender to impulses of the body in a freewheeling embrace of intense emotion. Is this truly a pedestrian approach, or could it be an intentionally Freudian image that sublimates sexual desire?

Jack's Dream of Summer (1997, p. 30), a memorial to Pratt's late father, bears personal references lamenting loss and the passage of time. The lettering on the side of the railcar identifies its home station as Topsail. The artist has long-standing emotional ties to the village; he attended school there in 1943 and spent the summers of 1939 to 1946 at Topsail Bay and nearby Bay Roberts, where he would listen to the sounds of nature "above the muffled rhythms of a distant train."[4] The car number 105 refers to 10 May (10/5), the date in 1963 when Pratt moved to Salmonier to establish his home at his father's former summer retreat. A puff of smoke emitted from the chimney of a Franklin stove inside the railcar could be contemplated as an allusion to his father's spirit.

4
Pratt, 174.

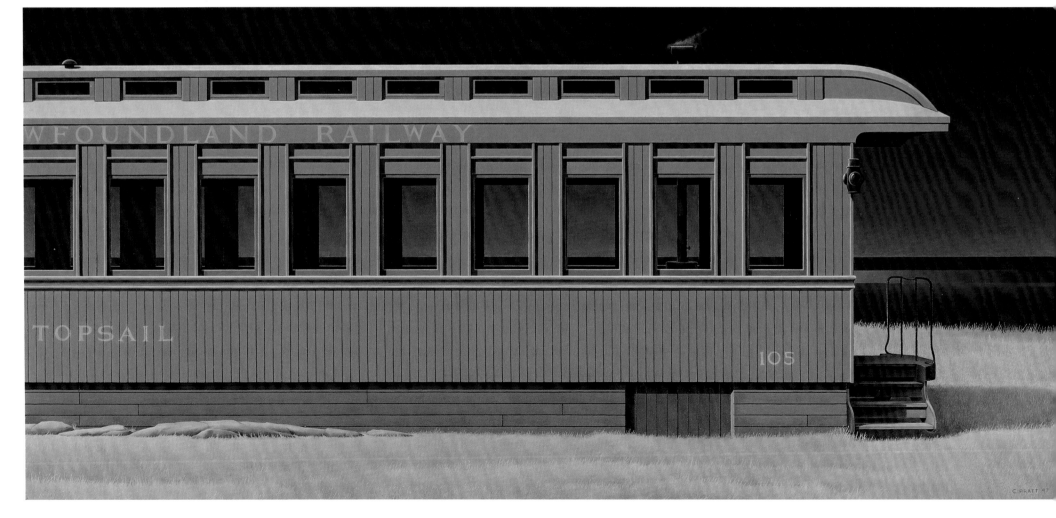

Ferry Terminal (1995, p. 31) is a recapitulation of *Station*, one of my most cherished images in art. The two paintings share uncanny resemblances – as if they were day and night versions of the same building interior shown from opposite directions – but differences between them indicate the kinds of adjustments Pratt has made in his recent production. *Station* relies on planar areas of flat colour and minimal detail. Lit by a bare bulb hanging in the washroom, the space is comparatively grim. *Ferry Terminal* advances the painterly craft to a higher science, providing every descriptive detail – right down to the wing-nuts securing the seating – and rendering complex illusions in the sunlight and shadows that punctuate the gleaming chairs and floor. The space is sanitized, spic and span, although the decor is a bit mundane, even miserly, reflecting how Pratt despises institutions like terminals, airports, and hospitals as a kind of purgatory – halfway stations where you must surrender your destiny to someone else, able to go neither forward nor back until released to do so by someone else.

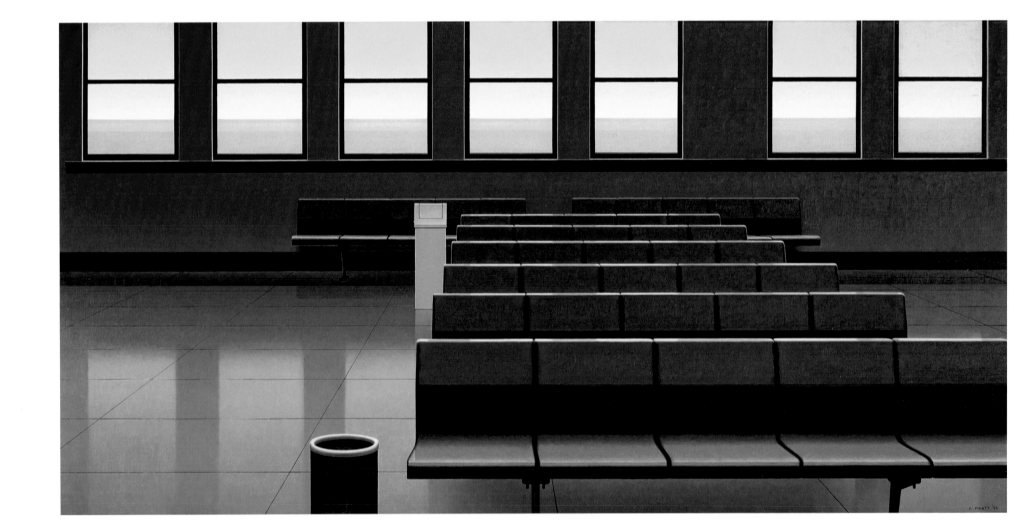

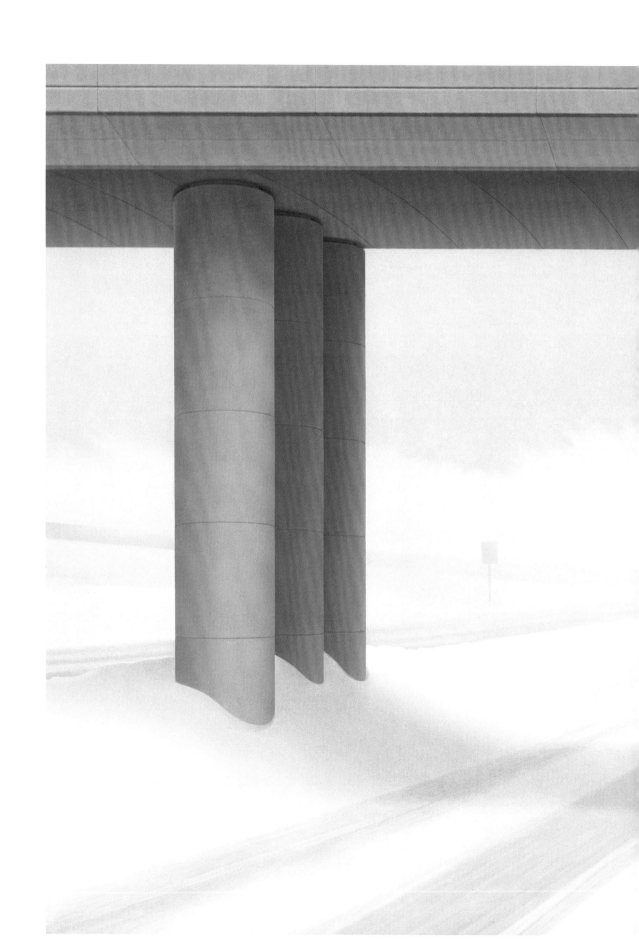

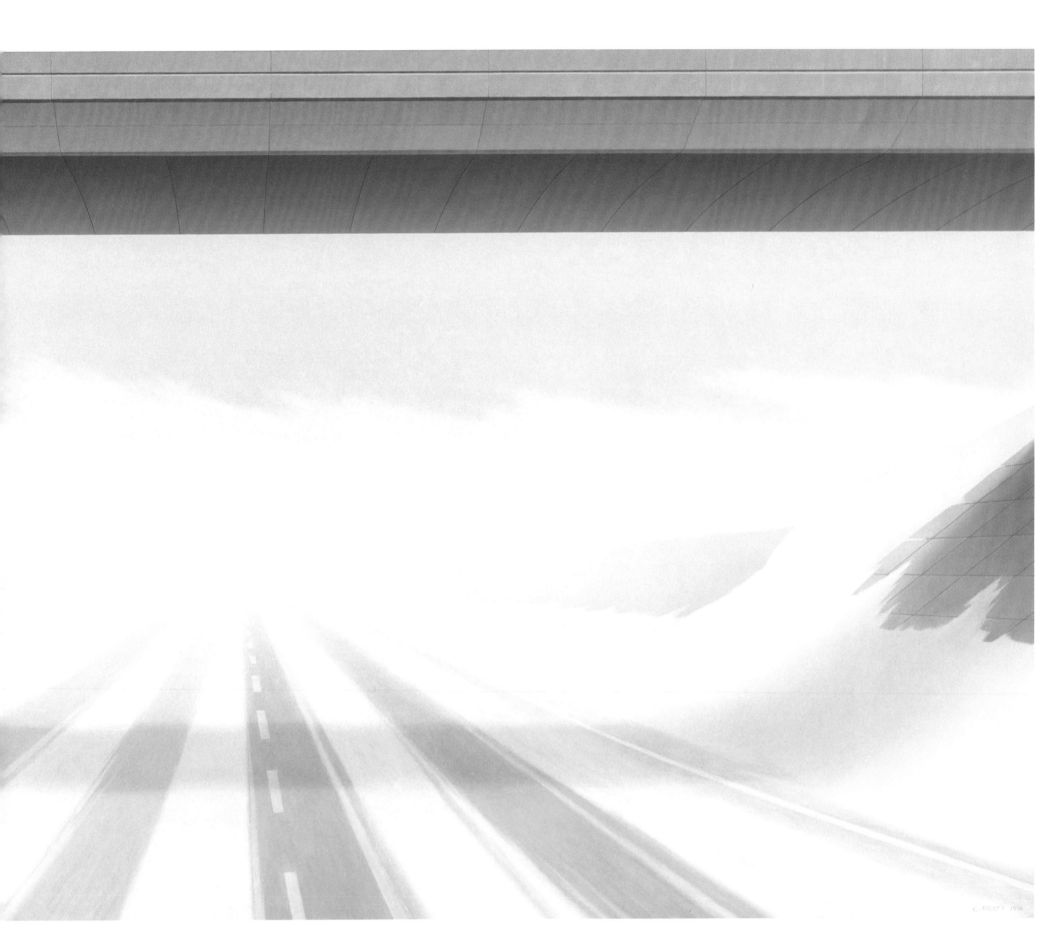

In *White-Out at Witless Bay Overpass* (1996, pp. 32–33), Pratt leaves behind his trademark classical precision to embrace romantic Whistlerian imprecision: concrete forms transubstantiate into blustery brushwork in our midst. With no idea what awaits us, we cross the boundary of the shadow cast by the overpass and hurtle directly into a bank of blinding white light. We should sense danger: ahead could be a slow-moving plough, an oncoming truck, or a moose. Or are we at the Pearly Gates? It's all of Pratt's measuring, his speculating on the transcendent and the eternal that's to blame. It comes down to this: we can perhaps *hope* to catch a glimpse of the infinite. With the passage of time, however, it becomes inescapably clear that we *do* grasp the nature of the finite.

Since his 1985 retrospective, Pratt has indulged in self-measure of his artistic worth. His constant yearning for new subjects and new approaches suggests that he is not yet fully at peace, not entirely sure that he has accomplished all he can. *Self-Portrait: Who is This Sir Munnings?* (1998, p. 35) asks us to participate in the assessment process. The title comes from Picasso, who dismantled the sting of critique levelled by an imperious British painter with the dismissive question, "Who is this Sir Munnings?" Well, *that* Sir Munnings was the one-time president of Britain's Royal Academy and a war artist of historic note. *This* Sir Munnings, the one in Pratt's self-portrait, chooses to lambaste himself. Like a stoic *Canadian Gothic*, he sports the Order of Canada badge that reflects his acknowledged professional accomplishments. Yet instead of accepting the praise of many decorations, he polishes his disappointments: at the bottom of the picture he affixes childhood images of himself and a friend who died in her twenties, complete with a line from Dylan Thomas that might be taken as a eulogy for a lost chance at love. Set against an ethereal white backdrop, Pratt's image – photocopied on tissue paper – is poised to dissipate. However, he still has battles to win and honours to restore: not for himself, but for the love of Newfoundland and Labrador. He's not ready to head through heaven's gate. So, it's back to the studio.

After fifty-plus years of sterling accomplishments and countless masterworks, Pratt is still pushing, still stretching. He makes adjustments, creating room to grow. Imploring himself to risk redefinition, he goes louder and quieter, bigger and smaller, expressive and restrained. His fans cheer him onward, upward.

Salmon River Bridge, Nova Scotia

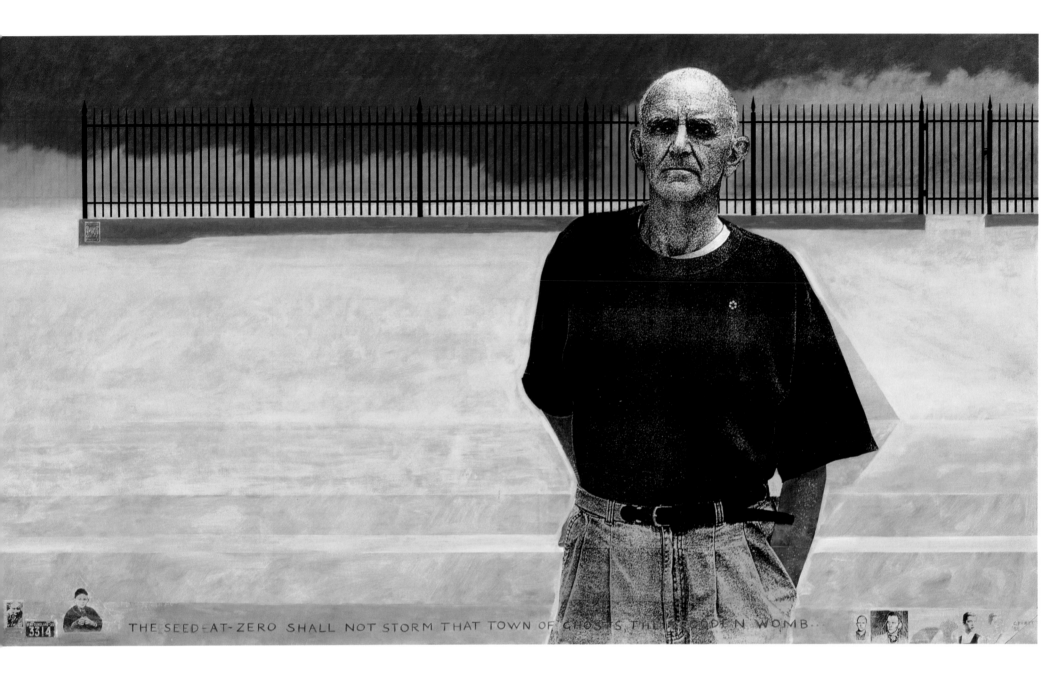

THE SEED-AT-ZERO SHALL NOT STORM THAT TOWN OF GHOSTS THE GOLDEN WOMB...

CHRISTOPHER PRATT IN THE POLITICAL LANDSCAPE

Josée Drouin-Brisebois

1
Cabot landed on the Atlantic Coast in 1497; the exact site has not yet been established.

2
Christopher Pratt, interview by Barbara Dytnerska, National Gallery of Canada, Ottawa, 17 November 2004.

When dozens of planes landed at the Gander Airport in Newfoundland on September 11, 2001, thousands of travellers, mainly Americans, found themselves stranded in a part of the world they had never seen. As locals took them into their homes, the birthplace of North America was in a sense rediscovered, over five hundred years after John Cabot's historical voyage led to the settlement of a continent.[1] Newfoundland is one of the world's largest islands, comparable in size to Iceland and Cuba. Gander airport, opened in 1938 near the island's northeast coast, was once known as the Crossroads of the World; it was a refuelling station for almost every plane flying between North America and Europe until the advent of jet aircraft in the 1960s. Today, Newfoundland and Labrador are at another kind of crossroads, holding on to traditional outport culture while feeling the effects of modernization – new communications, industrial developments, and the construction of highways, suburbs, and strip malls. This is the place where Christopher Pratt was born and has lived most of his life. This is the place he has painted for over fifty years.

Christopher Pratt's images are situated between reality and fiction. On the one hand, they denote a postmodern interest in locality and the distinct cultural identity of Newfoundland and Labrador as Pratt depicts the natural and social landscape around him. On the other, they are largely the products of his imagination, as the world he represents is often conjured from memory, then filtered and clarified through his search for order and simplicity. In his art, Pratt does not merely illustrate his observations of Newfoundland and other places, but actively responds to his surroundings. He explains:

> With respect to the origins of my work I think that it's fair for me to say that my work is essentially autobiographical, and I say that because I've never really been preoccupied with the history of art, or art about art. My work essentially comes from my environment, but you have to take a very broad view of the term environment. It's obviously not just my geographical environment, although that's very important. It's also the social environment, the family environment of my childhood, memories that go back to there, and experiences that followed. It's also the environment of things that I have read and encountered subsequently. But the bottom line really is that my work is the response to my life.[2]

Pratt's production is not generally interpreted as political, and the artist himself does not consider his paintings to be overt sociological statements. He does, however, see them as reflections of his experiences, and on that basis I will argue that political concerns underlie much of his artistic practice.

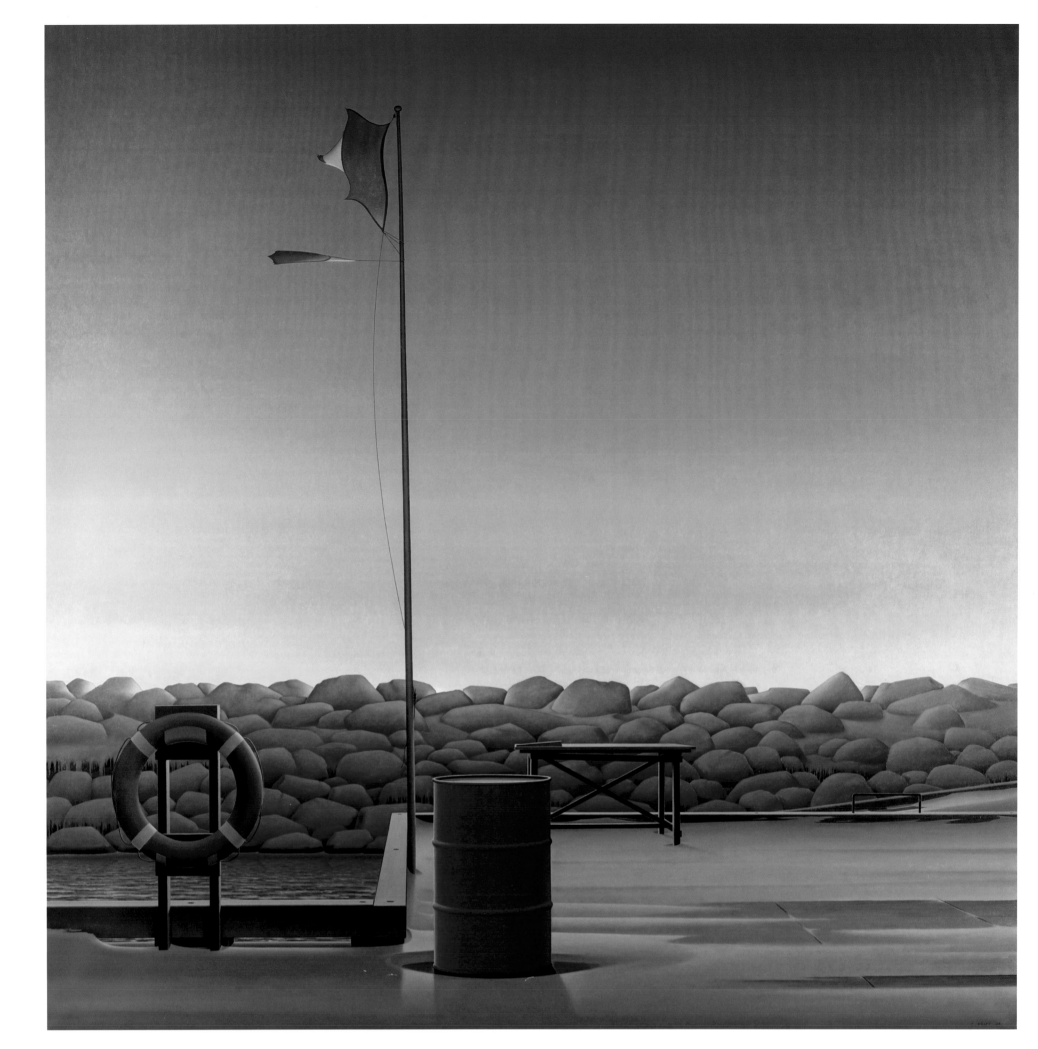

Pratt loves his native land, and his work is deeply ingrained in the place and the circumstances of living there. In the process of witnessing events that have transformed Newfoundland and Labrador, then representing his environment from an autobiographical stance, Pratt's social and political concerns necessarily become incorporated in his work. Pratt is keenly aware of Newfoundland's history and current affairs. For him, as for many Newfoundlanders, past events, especially Confederation, still resonate in daily life on the island. To fully appreciate the political aspects of Pratt's work, it is important to consider the basic outlines of Newfoundland history.

Archaeological evidence indicates that Labrador was inhabited as early as 7000 BCE, and that the Beothuks, the aboriginal people of Newfoundland, were established on the island when Viking explorers arrived circa 1000 CE.[3] Until the early eighteenth century, Newfoundland was primarily a British fishing station; historian D.W. Prowse described the island in the years 1497 to 1610 as "a kind of no man's land, without law, religion, or government...only ruled in a rough way by the reckless valour of Devonshire men, half pirates, half traders."[4] This important resource became the cause of many disputes, especially between Britain and France.[5] Settlement was discouraged because it was thought to impede the development of the offshore fishery, and a trade act, in place until 1824, outlined severe penalties for permanent settlers.[6] Still, by the early 1860s, about 140,000 people lived on the island.[7]

The first formal administration in Newfoundland was established in 1633 by Charles I; under Government by the Fishing Admirals, the captain of the first ship to arrive each year at any fishing port was to be admiral of the harbour for that season. It continued until 1729, when Britain appointed Captain Henry Osborne as the first governor of Newfoundland. In 1833 Representative Government began, with an appointed Legislative Council and an elected House of Assembly, and continued until 1855, when it was replaced by a fully elected Responsible Government. In 1933 England appointed a Royal Commission to enquire into the poor financial condition of the country; the commission recommended that a board of experts govern until the nation became solvent again. Under an appointed Commission of Government, six commissioners (three from England, three from Newfoundland) and a governor oversaw Newfoundland and Labrador until the late 1940s.[8] In June 1948 a referendum was held to decide between Responsible Government, Commission of Government, and Confederation with Canada. The results were inconclusive; Responsible Government won the first round, but without a clear majority. A month later a second referendum was held; Commission of Government was dropped from the ballot, and by a slight majority, Newfoundlanders chose Confederation.[9] On 1 April 1949, Newfoundland became the tenth Canadian province, with Joseph R. Smallwood as its premier.

Reaction to Confederation was mixed: divisions, sometimes irreparable, developed in families, communities, and regions across the new province. The Confederation campaign led by Smallwood had emphasized the increased social services that Newfoundlanders would receive through union with Canada, but according to a 2003 provincial government report:

3
Archaeological evidence indicates that Maritime Archaic Indians first settled in Labrador as early as 7000 BCE and had migrated to the Island of Newfoundland by 3000 BCE. Palaeo-eskimos moved into Labrador around 1800 BCE, and onto the island around 800 BCE. The Beothuks numbered about one thousand at the time of European contact in the fifteenth century; in 1829 they became extinct. Dr. Melvin Baker, "History of Newfoundland and Labrador Summary Chronology of Events," *Royal Commission on Renewing and Strengthening Our Place in Canada.* Research Papers, March 2003: 3. <http://www. exec.gov.nl.ca/royalcomm/research/pdf/baker chronology.pdf> 15 January 2005.

4
Prowse, xv. Dr. Jerry Bannister offers a cautionary note about Prowse's *History:* "The story of Newfoundland was, according to Prowse, a narrative of the long struggle for control over the island between the tyrannical West Country merchants along with their allies in the British government, on the one hand, and the humble settlers and their political champions, on the other...It continues to exert a heavy influence over the array of literary and commercial constructions of the island's history, thereby providing the basic prism through which Newfoundland nationalism has been reflected in both the arts community and the thriving cultural tourism industry." "The Politics of Cultural Memory: Themes in the History of Newfoundland and Labrador in Canada, 1972–2003," *Royal Commission on Renewing and Strengthening Our Place in Canada.* Research Papers, March 2003: 125. <http://www.exec.gov.nl.ca/royalcomm/research/ pdf/Bannister.pdf> 15 January 2005.

5
Although Sir Humphrey Gilbert claimed the island for the British Crown in 1583, England met with swift and continuing resistance from France, which also felt it had the right to Newfoundland. As a result of the struggles between the two powers, the city of St. John's changed hands between them in the years 1696, 1697, 1705, and 1762, and was essentially destroyed each time. In 1763, following the

Seven Years' War, England emerged as the victor. Baker, 5, and "Economic History of Newfoundland," *The Encyclopedia of Canada. Newfoundland Supplement,* W. Stewart Wallace, ed. (Toronto: University Associates of Canada, 1949); sourced from "Newfoundland Economy: Agriculture, Fisheries, Lumbering, Pulp and Paper, Sealing, Trade and Transportation 1497– 1949," Claude Bélanger, ed., *Newfoundland History.* <http://www2.marianopolis.edu/ nfldhistory/Newfoundland%20Economy.htm> 15 January 2005.

6
Charles I decreed that "this great Colony was not to be inhabited, that any chance settlers remaining should be persecuted, hampered, and impeded in all their labours and industry, that though they were fishermen and had to live by the sea, it was solemnly decreed that none of them should reside within six miles of its shores...in order that West Country fishermen should catch fish on the coast, and a few courtiers make their fortune." D.W. Prowse, *A History of Newfoundland from the English, Colonial and Foreign Records.* (1895; reprint, Belleville, Ont.: Mika Studio, 1972): 136.

7
Library and Archives Canada, "Newfoundland," *Canadian Confederation.* <http://www.collectionscanada.ca/ confederation/023001-2230-e.html> 5 May 2005.

8
In 1927 the British Privy Council confirmed Newfoundland's legal ownership of Labrador, against a claim from Canada on behalf of the province of Quebec.

9
The final tallies of the June 1948 referendum were: Responsible Government, 44.6% of the vote; Confederation with Canada, 41.1%; Commission of Government, 14.3 %. One faction even favoured annexation to the United States, but this option never made it onto the ballot. In the July 1948 referendum, Confederation with Canada won with 52.3% of the vote. Library and Archives Canada, "Newfoundland."

The people [of Newfoundland] did not have a good understanding of the draft terms of union proposed by Canada. It was a more general sense of what Confederation would mean for their daily lives that inspired a majority to have faith in Confederation. People appreciated that there were many risks, ranging from increased taxation to a weakening of local identity. But people hoped that Confederation would bring a standard of living comparable to that of Canadians and provide a real chance for Newfoundland to realize its true economic potential.[10]

Historian Miriam Wright has studied the profound transformations in Newfoundland society after Confederation. Cash payments were infused through federal programs such as Family Allowance, Unemployment Insurance, and Old Age Pensions, while transportation, communications, education, and health care were expanded. Despite these improvements, though, Wright explains that "Newfoundland remained on the margins of North American prosperity." Although its population "increased dramatically," so too did the number of people leaving the province in search of work – an average of three to four thousand yearly between 1957 and 1971. Most of the revenues from natural resources (especially mining and forestry) left the province, and employment in the resource sector did not substantially increase. As a result, "by the early 1970s, Newfoundland was still heavily dependent on transfer payments from Ottawa."[11]

Some of the most significant social changes resulted from the resettlement program, a measure intended to reduce the cost of providing services to small outport fishing communities. In the 1950s and early 1960s, the provincial government offered financial assistance to people willing to move to larger centres of their choice. After 1964, following the theory that focus on designated "growth centres" would enhance economic development, a joint federal-provincial program encouraged people to relocate to specific cities. The program was controversial, but thousands of people migrated, and "by the early 1970s, there were some two hundred fewer rural communities in Newfoundland than there had been at Confederation."[12]

A key consequence of these upheavals was the resurgence of Newfoundland Nationalism. Originally an early-nineteenth-century development intended to support the interests of native-born islanders in a campaign for greater local autonomy through representative government, today Newfoundland Nationalism is inherently critical of the Canadian government's management of the province. Historian Dr. Jerry Bannister summarizes the arguments that underlie Newfoundland Nationalist rhetoric:

Newfoundland has a poor economy but is rich in natural resources; its poverty is due to incompetent resource management by state agencies based outside the island; local authorities have superior technical expertise, moral commitment, and popular legitimacy; the absence of proper policies and administration is caused by the lack of sufficient local control over resource exploitation and allocation; thus the key to prosperity is the transference of power to local political institutions.[13]

10
Our Place in Canada. Royal Commission on Renewing and Strengthening Our Place in Canada. Final Report, June 2003: Chapter 2, "Expectations as We Joined Canada," 16. <http://www.exec.gov.nl.ca/royalcomm/finalreport/pdf/Final.pdf> 15 January 2005.

11
Miriam Wright, "Newfoundland and Labrador History in Canada, 1949–1972," *Royal Commission on Renewing and Strengthening Our Place in Canada.* Research Papers, March 2003: 95–96. <http://www.exec.gov.nl.ca/royalcomm/research/pdf/history.pdf> 15 January 2005.

12
Wright, 99.

13
Bannister, 147.

Christopher Pratt has observed Newfoundland's recent political and social changes first-hand, and his point of view is informed by Newfoundland Nationalism. Born in St. John's in 1935, his roots in the island run deep; his mother's family had settled there as early as 1595. Curator Joyce Zemans observes that Pratt's "imagination was formed by the flat barren landscape of Newfoundland's Avalon Peninsula and by the sea that encircles and permeates it." She adds, though, that "a person's world view, his *Weltanschauung*, is determined not only by his physical surroundings but by his own nature and by the events and conditions of his life."[14] For Pratt, one of these conditions is his self-identification as a Newfoundlander; he became a Canadian citizen only after Confederation, when he was thirteen, and his immediate family voted against union with Canada. According to curator David Silcox, "the issue of Confederation is still a contentious one that contributes to the tenuousness of Pratt's search for identity."[15]

How is it, though, that Pratt's images – so tranquil and controlled – can be interpreted as political? Philosopher Yves Michaud considers how an artist may express political commitment through artwork and direct action both, but cautions against equating "political artist" with "political art." He explains:

> The problem with this double commitment is that the coherence between the two spheres is not logically guaranteed. This means that the political message expressed is not necessarily congruent with the form, and that the individual's effective commitment is not necessarily related to his or her artistic commitment.[16]

Michaud illustrates his argument with the examples of Paul Cezanne and social realism:

> In political terms, Cezanne was a reactionary, trapped in provincial bourgeois conservatism; but his painting was deeply revolutionary from the point of view of the history of formal evolutions and opened the way to Cubism and abstraction. Inversely, realist socialist art demonstrates that one can be very conventional stylistically and still be politically committed to the proletariat.[17]

Following Michaud, Pratt's formal concerns can be described as conventional in that they derive from the lineage of Western classical tradition and its characteristic balance, order, and discipline. While Pratt is not an activist, his political views stem from Newfoundland Nationalism, which embodies his concern about the future of the province's society, economy, and ecology.

Much has been written about the importance of design and abstraction in the composition of Pratt's images. To a certain extent, formal qualities can be interpreted as the subject of his paintings, in that the flatness of the surface, the framing devices, and the properties of paint are paramount. Lawren P. Harris – one of Pratt's teachers at Mount Allison University and a fervent advocate of abstraction – instructed him on modern painters' concern to make form, rather than content, the true subject of art.[18] Given the importance of measuring and precision in Pratt's work, it is not surprising that art historians have associated him with the American Precisionists, who used familiar imagery to explore design

14
Joyce Zemans, *Christopher Pratt: A Retrospective.* (Vancouver: Vancouver Art Gallery, 1985): 9.

15
David P. Silcox, *Christopher Pratt.* (Scarborough, Ont.: Prentice-Hall, 1982): 35. [Silcox 1982]

16
Yves Michaud, "Art and Politics: Resistance and Re-Appropriation," in *Resistance: Third International Symposium on Contemporary Art Theory.* (Mexico City: SITAC, 2004): 212.

17
Michaud, 212.

18
Zemans, 20.

concepts and formal abstraction.[19] The tension between the figurative and the nonfigurative is prominent in Pratt's work: although his pictures are representational, he incorporates visual strategies from the tradition of abstraction, such as simplification of form, framing devices, a reduced palette, and application of colour in gradual modulations to accentuate the flatness of the surface. He also strips away details from the subject depicted in order to create a more generalized and ambiguous image.

Before studying fine arts at Mount Allison University and the Glasgow School of Art, Pratt studied pre-engineering at Memorial University, and during the summers of 1957 and 1958, he worked as a construction surveyor at Argentia Naval Station, the American naval base on Placentia Bay. That training and experience had an important and lasting impact on his production: according to Pratt, drafting and surveying techniques are still evident in the design and physical balance of his work.[20] They also inform his painstaking process of constructing images, as Silcox describes:

> In Pratt's case, a geometric structure is engineered, stressed, proportioned, calculated, and balanced with the care one would bring to the design of a bridge or the cutting of a diamond. Precision in this degree means measurement, and Pratt charts his course in mathematical detail, computing sections, recessions, intersections, and focal points with actuarial glee, although he invariably exercises a final visual correction. He uses squares, circles, rectangles, fulcrums, levers, incidences of reflection, and golden section divisions, because they have served other artists successfully in the past and serve him well in organizing shapes mentally and graphically.[21]

Although Pratt uses geometry in his creative process, he clarifies its role, saying: "Most of the time I use them after the fact to analyze and confirm my intuitions, rather than to determine the original structures, intervals, etc. of the image."[22] The first sketches for a painting are often mere scribbles made on a small piece of paper as the artist remembers a place or event. Sometimes the idea is developed from notes he makes about things he has seen, or from potential titles for paintings. In this respect, surveying, defined as "the study or practice of measuring altitudes, angles, and distances on the land surface so that they can be accurately plotted on a map," becomes a metaphor for Pratt's process of translating, adjusting, and ultimately recording his personal experiences.

This metaphor can be pursued further by considering how surveyors use specialized instruments such as transits and theodolites to measure horizontal and vertical angles. These telescope-like devices present the viewer with a framed representation of the landscape that is both seen from a particular point of view and, by means of their distancing effect, removed from reality. Measuring devices and mathematical formulas have a long history in Western art: artists have used them since the Renaissance to create perspective and represent three-dimensional space. In the early fifteenth century, Leon Battista Alberti wrote in *Della Pittura*, his influential treatise on painting, that the picture plane should be treated like a transparent glass, a window through which the visual rays pass.

19
See Zemans for a discussion of the association between Pratt and the Precisionist tradition.

20
Pratt in Silcox 1982, 120.

21
Pratt in Silcox 1982, 25.

22
Pratt clarifies that he does not necessarily understand the mathematics of the structures and diagrams he uses, but knows how to piece them together graphically. Written communication with the author, 5 April 2005.

Going Away (Curved Corridor)
1987

Untitled (Curved Corridor) 1987

Perspective Study for "Pedestrian
Tunnel" 1989

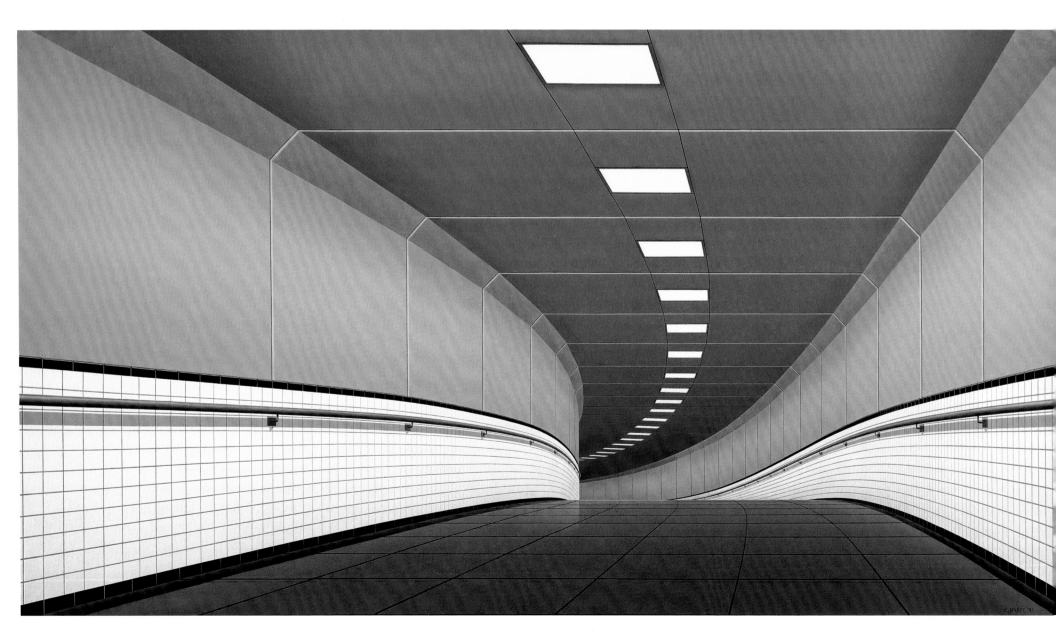

While Pratt takes a decidedly calculated approach to his compositions, his intention differs from Alberti's in that he is not trying to represent reality as such; he aims not to create an illusion of the real, but to define the qualities of experience – the mood or feeling – of a place or event. And although carefully constructed, Pratt's paintings do not readily reveal themselves; the order, formality, and idealization in his works are a smokescreen for what lies behind, or beneath. As Silcox writes: "I would offer a word of caution about [Pratt's] writings, as for his paintings: while he seems crisp and straightforward, he is still oblique. He appears to be confessing all, but the whole truth is often elusive or disguised."[23]

The experience Pratt consistently creates in his work is one of disquiet and isolation. Whether it is because boats are landed, interiors empty, or landscapes utterly still, something is always out of season, out of context, or just a bit "off." What lies beneath the surface, what will happen next, is up to the viewer to decide. The resulting psychological dimension of Pratt's paintings demands that we spend time with them in order to decipher what seems to be going on.

Pratt usually represent places in Newfoundland, although many of his works are generalized to the point that their locations are not identifiable. Others are related to his experiences while travelling and depict, for example, the inhospitable atmosphere of waiting areas in *Station* (1972, p. 13) and *Ferry Terminal* (1995, p. 30), and a claustrophobic airport passageway in *Pedestrian Tunnel* (1991, p. 42). Pratt explained the unsettling feeling he wanted to create in the latter work: "I did a lot of sketches based on experiences in airports and hospitals and tunnels underground. Then I started drawing curves intuitively…trying to describe a vortex and a sense that the thing went on forever, never resolving, that there was nothing at the end of it, darkness nor light, that it could only return into itself."[24]

23
David Silcox, introduction to Christopher Pratt, *Christopher Pratt: Personal Reflections on a Life in Art.* (Toronto: Key Porter, 1995): 11.

24
Christopher Pratt, *Christopher Pratt: Personal Reflections on a Life in Art,* 186. [Pratt 1995]

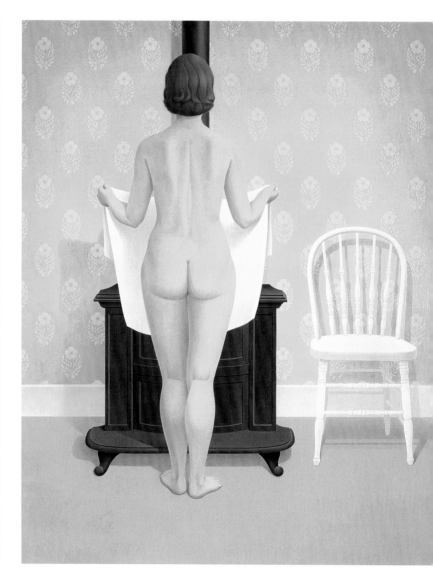

Another portion of Pratt's oeuvre deals with the female figure, depicting young women from his community in paintings like *Woman at a Dresser* (1964, p. 44), *Woman and Stove* (1965, p. 44), *Girl in the Spare Room* (1984, pp. 46–47), and *Woman Wearing Black* (1972/1989, p. 45). These are exceptional in Pratt's production because in them, there is usually no feeling of strangeness or disjunction: the women are self-absorbed and engaged in activities, such as washing, dressing, and resting, that are appropriate to their surroundings. Pratt has produced significantly fewer figure paintings in the last twenty years; *Girl with a Black Towel (Pink Madonna)* (1973/1996, p. 107) and *Blue Dianne* (1984/1996, p. 106), both based on earlier drawings, are two rare recent examples.

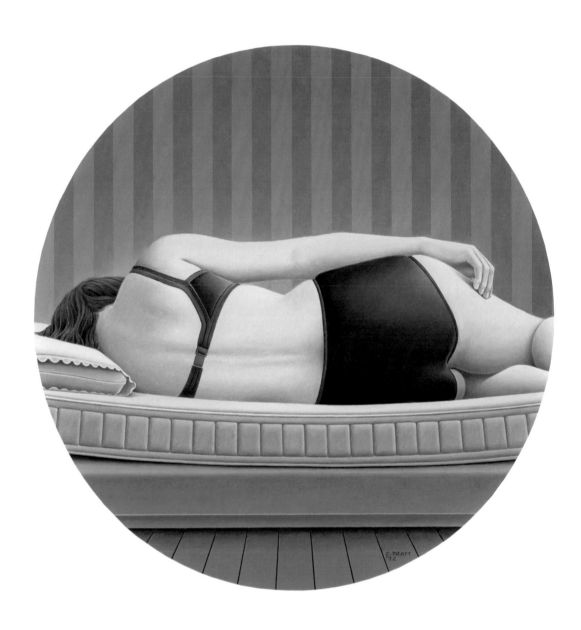

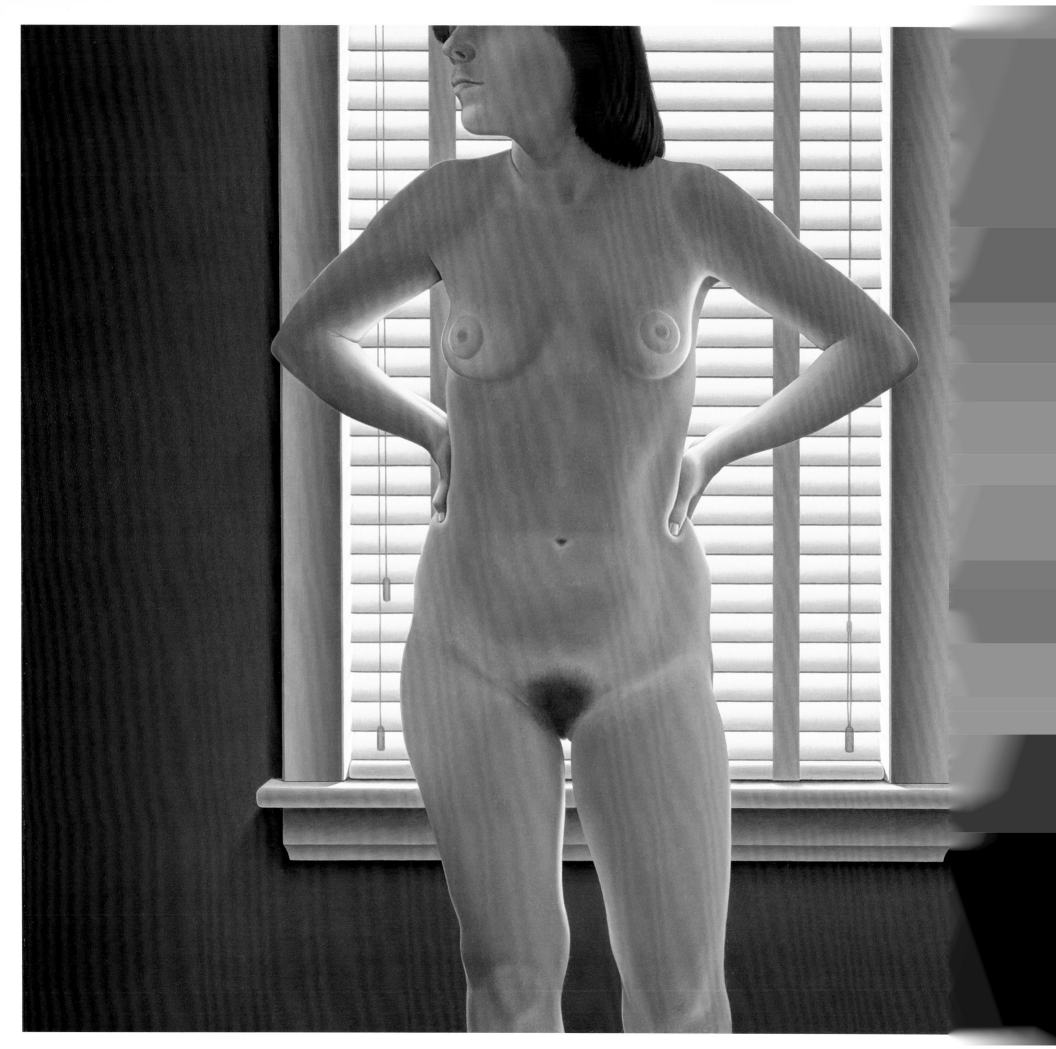

25
Pratt 1995, 23.

In contrast to his paintings of women, the sense that things are out of place may be most overt in Pratt's depictions of boats. Rarely shown immersed in water, their "natural" habitat, instead they may be grounded on a beach (*Boat in Sand*, 1961, fig. 3), suspended in a warehouse (*Big Boat*, 1986–87, pp. 22–23) or a boathouse (*Big Cigarette*, 1993, p. 21), or wintering on stilts (*Four White Boats: Canadian Gothic*, 2002, p. 49). Rather than describing the activity of boating, Pratt's vessels become objects that are at once autonomous, abandoned, and trapped. In the early silkscreen *Boat in Sand*, the beached fishing boat – having lost its primary function, lying empty and vulnerable to the elements – begs a more political interpretation. With reference to post-Confederation upheavals in Canada's newest province, Pratt wrote: "I did this print in 1961, at a time when things were changing very rapidly in Newfoundland. It seemed to me that traditional and viable social structures were being systematically discredited."[25] In rural Newfoundland, small boats had been the backbone of the economy and were considered far more important than cars or trucks. In *Boat in Sand*, the stranded vessel becomes a metaphor for the desolated coastal towns whose communities were urged by the government to abandon their homes and their livelihoods to resettle in larger cities.

Fig. 3
Boat in Sand, 1961.
Colour serigraph on wove paper, 47.9 × 73 cm.
National Gallery of Canada, Ottawa

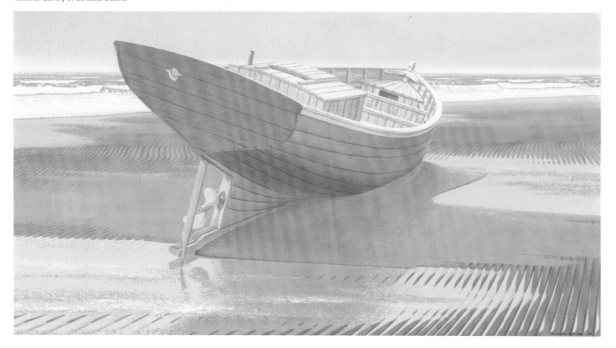

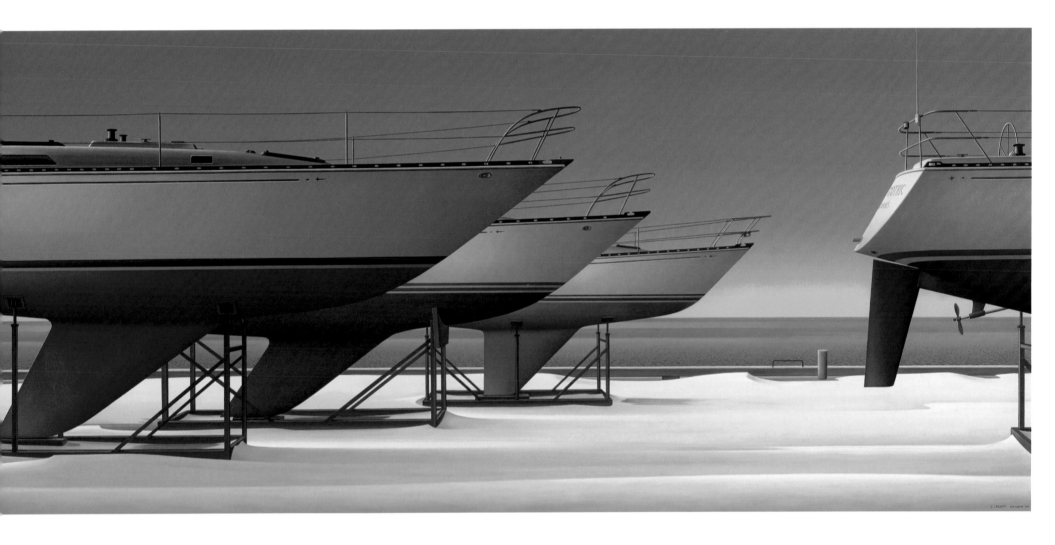

26
Pratt 1995, 64.

Another early work, *Shop on an Island* (1969, p. 51) is, like all of Pratt's images, carefully designed and constructed. The rhythm of vertical and horizontal lines creates visual tension as the eye travels back and forth from the empty shelving to the display case rail and through the window to the horizon line beyond. The frontal composition and flatness of the image create an uneasy, even claustrophobic feeling; the only refuge lies in the expanse of ocean, and even that must be negotiated with the barriers of the rail and window muntins. Where one expects a store to be filled with goods for sale, Pratt's shop is disturbing for situating the viewer in an empty space. The sense of isolation is palpable, and the shop, like the vessel in *Boat in Sand*, becomes a metaphor for the abandonment of Newfoundland coastal towns. As Pratt observed:

Communities that in their heyday harboured (say) 200 souls would have become substantial towns had more people found it possible to stay, but the resources of this Island, at least as they were managed, kept only a privileged few in style. Having to leave the outports wasn't new; abandoning whole communities was. That started with "resettlement" in the 1960s: the Smallwood government both enticed and forced people to move from isolated settlements to places where the expectations of Confederation could, in some small way, be met. Seemingly overnight, there were abandoned villages all around the coast. People just packed up and left, leaving behind their way and means of life, often towing their houses behind their boats like huge, windowed whales. In many places only a few larger buildings remained, churches and schools and shops. They were like well-found ships mysteriously abandoned at sea: sound, seaworthy, but with no sign of crew. They stood as memorials until wanderers and the weather tore them down.[26]

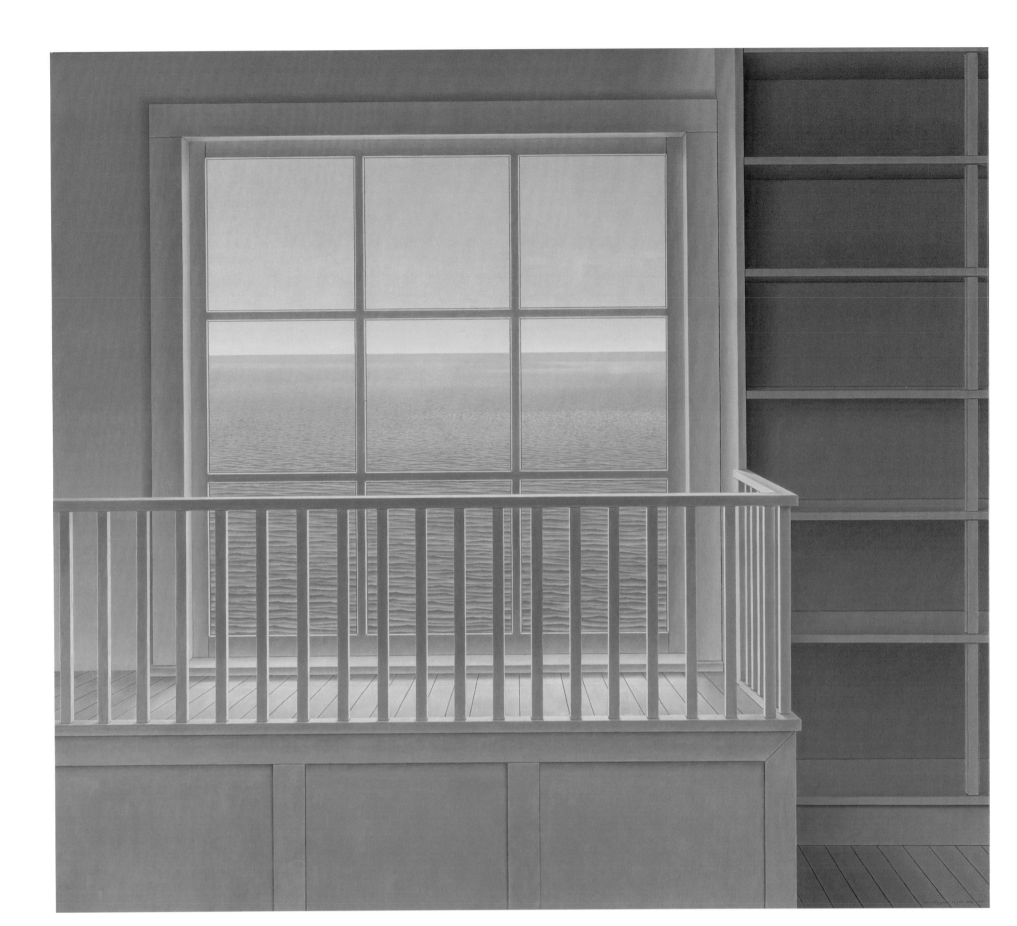

In his more recent production, Pratt has continued to express his concern for how traditional ways of life in Newfoundland and Labrador are changing, and for the social, economic, and ecological challenges faced by his home province. *Whaling Station* (1983, pp. 18–19) is based on an experience Pratt had in 1972 while visiting the abandoned Hawke Harbour whaling station on the eastern coast of Labrador. Built in 1905, all that remained of the station when Pratt saw it was a clapboard building where inside, wooden bunks lined the walls like shelving, and the names, thoughts, and fishing statistics of whalers past had been immortalized in the form of graffiti. In his studies for the painting, Pratt recorded some of their writings: "July 23 2 wales, August No wales, 14 days to go." The latter inscription, a countdown of days to freedom, suggests the men felt like prisoners of sorts. Overtop that graffiti, they expressed themselves even more explicitly with the words "Fuck Hawke Harbour." The *Whaling Station* studies (p. 53) reveal that the work was originally conceived as a triptych, in which a main panel depicting bunks would be followed by one representing the graffiti-covered wall, and another representing the nighttime darkness of the station. In the final painting, only the main panel remains, with its intersecting horizontal and vertical lines of simple wooden bunks cleansed of their graffiti, of their narrative content. The original concept has been abstracted to the point that the title of the painting offers our only real clue to the purpose of the setting.

In this example of Pratt's filtering process, the essence of the place is translated into the colour and structure of the image. The atmosphere of the station is expressed primarily through a grey mauve colour he associates with "the grease- and blood-stained slipway and the rusting, oil-stained tanks and flensing blades" he remembered seeing there.[27] As for structure, Pratt explained: "I kept the bunks and their measured intervals because, although I knew that there could be no comparison between the cramped, squalid boredom of a whaling station bunkhouse and a World War II extermination camp, I was thinking about the calculations of the Holocaust."[28] Together, the monochromatic colour scheme and spare, ambiguous space give *Whaling Station* a sense of eeriness and darkness.

Like the empty shelving in *Shop on an Island*, the empty bunks in *Whaling Station* speak of isolation and abandonment, of a place that once had a purpose but has now been left behind. Pratt describes his interest in settings like this: "I am fascinated with the many places in Newfoundland that have been abandoned, standing empty and cavelike as if something has frightened or spirited everyone away."[29] Hawke Harbour and other whaling stations were built, then abandoned, following the ebb and flow of the East Coast commercial whaling industry over the course of the twentieth century. In 1972 a Canadian moratorium marked the official demise of more than four hundred years of traditional subsistence whaling and modern commercial whaling in Newfoundland and Labrador coastal waters. Documenting such a profound economic and social shift, *Whaling Station* is more than a remnant of a vanishing way of life; it stands as an elegy to the whalers themselves.

27
Pratt 1995, 147.

28
Pratt 1995, 147.

29
Pratt in Silcox 1982, 88.

Graffiti at Hawke Harbour 1972

Study No. 1: Hawke Harbour 1972

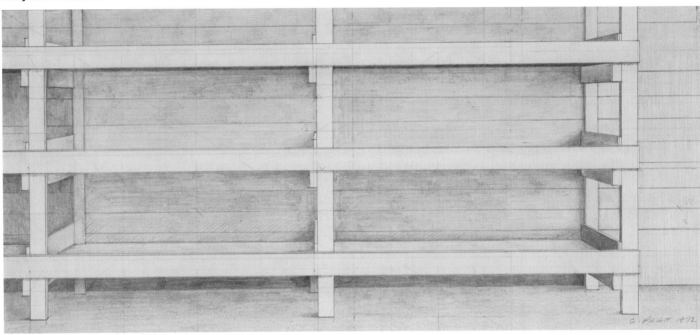

Study for "Hawke Harbour"
("Whaling Station") 1978

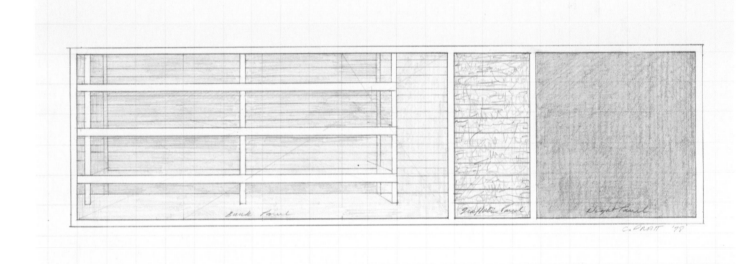

Newfoundland's strategic location on the Atlantic coast made the island a vital part of the North American continental defence strategy, especially during World War II. In 1941, it became the site of several American and Canadian military bases; a naval station and an army base were constructed in Argentia, near Placentia Bay on the southwest coast of the Avalon Peninsula. Twice – in 1997 and 1999 – Pratt depicted the abandoned American bunker in Argentia that was closed in 1994. *Argentia Bunker, August 1989* (1997, p. 54) presents a close-up view of the cement structure, while *Military Presence* (1999, p. 55) shows it from a distance. In contrast to the timeless quality of *Whaling Station* and other works representing buildings, in *Argentia Bunker* Pratt focuses on details such as the rust stains on pipes, metal fixtures, and walls, and the lettering on a weathered warning panel, in order to emphasize the structure's dilapidated state. In *Military Presence*, the bunker and remains of a runway control tower are shown in their entirety, surrounded by weeds and wild grass. Behind the structures Placentia Bay is visible, and hovering above them is a threatening, endless sky. The bunker and tower, as seen from a distance, become anomalies in the landscape: imposing, indestructible, and alone.

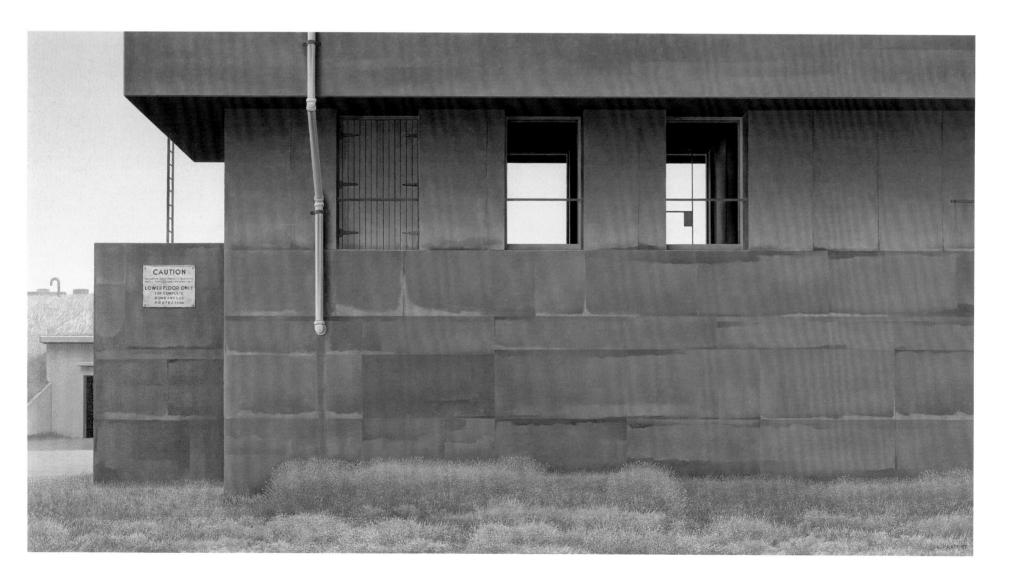

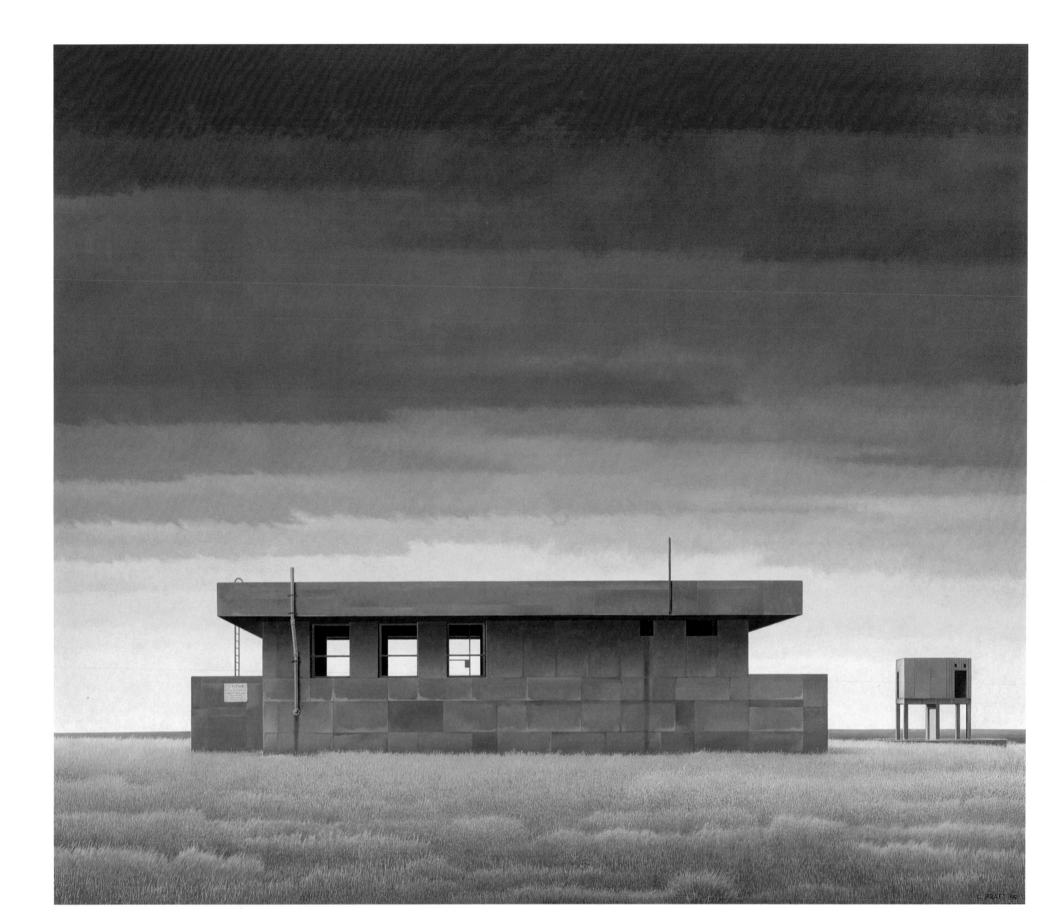

30
Quoted in Zemans, 40. Argentia also inspired
the painting *Federal Area* (1975).

The Canadian and American military bases had a significant impact on Newfoundland. Although the construction of facilities and spending by military personnel gave a boost to the island economy, some Newfoundlanders resented their presence, especially the residents of Argentia who were forced to relocate to nearby villages. Pratt himself worked as a surveyor at the American naval station on Placentia Bay, and he remembered how the experience affected him: seeing the "almost ghetto-like" atmosphere – monotonous buildings, barren yards, and chain-link fencing everywhere – he was "taken by the idea of that sort of an institution, [with] its physical oppressiveness and its indifference to human values."[30] Painted the same year as *Military Presence*, *The Americans: Off Base Housing*

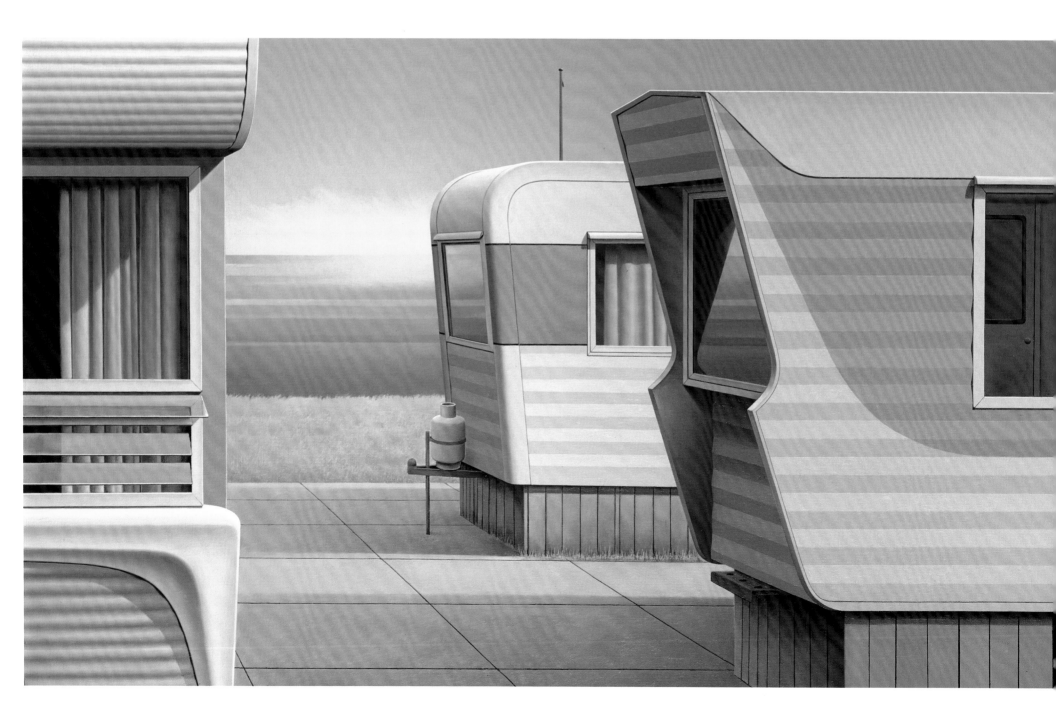

(1999, pp. 56–57) presents a seaside trailer park that would temporarily house military personnel and their families. In Pratt's image, natural and artificial elements compete with each other; the mobile homes, landed on concrete slabs, appear strange, even unsightly, in their picturesque setting. The reflection in the green trailer's darkened window recalls the play of reflections in the earlier *Subdvision* (1973, p. 57), to similar effect: just as homes in suburban developments seem to go on forever, so do the rows of trailers. While *The Americans* documents the presence of Americans and the conditions many of them lived in while stationed in Newfoundland, Pratt also saw the painting as an observation on the hierarchal conformity and sociological impermanence of military life.[31]

31
Pratt, written communication.

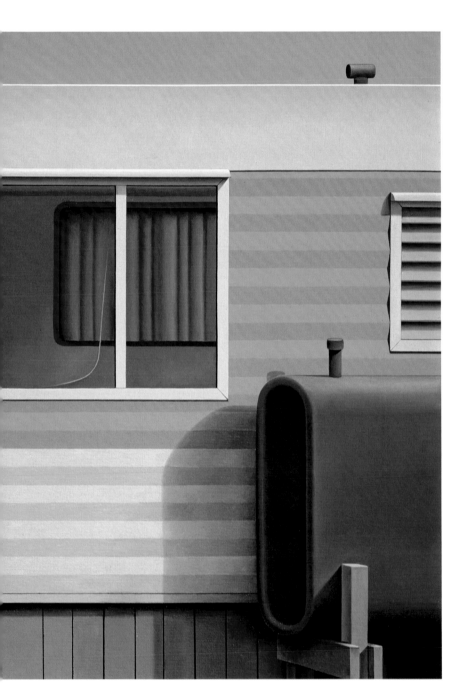

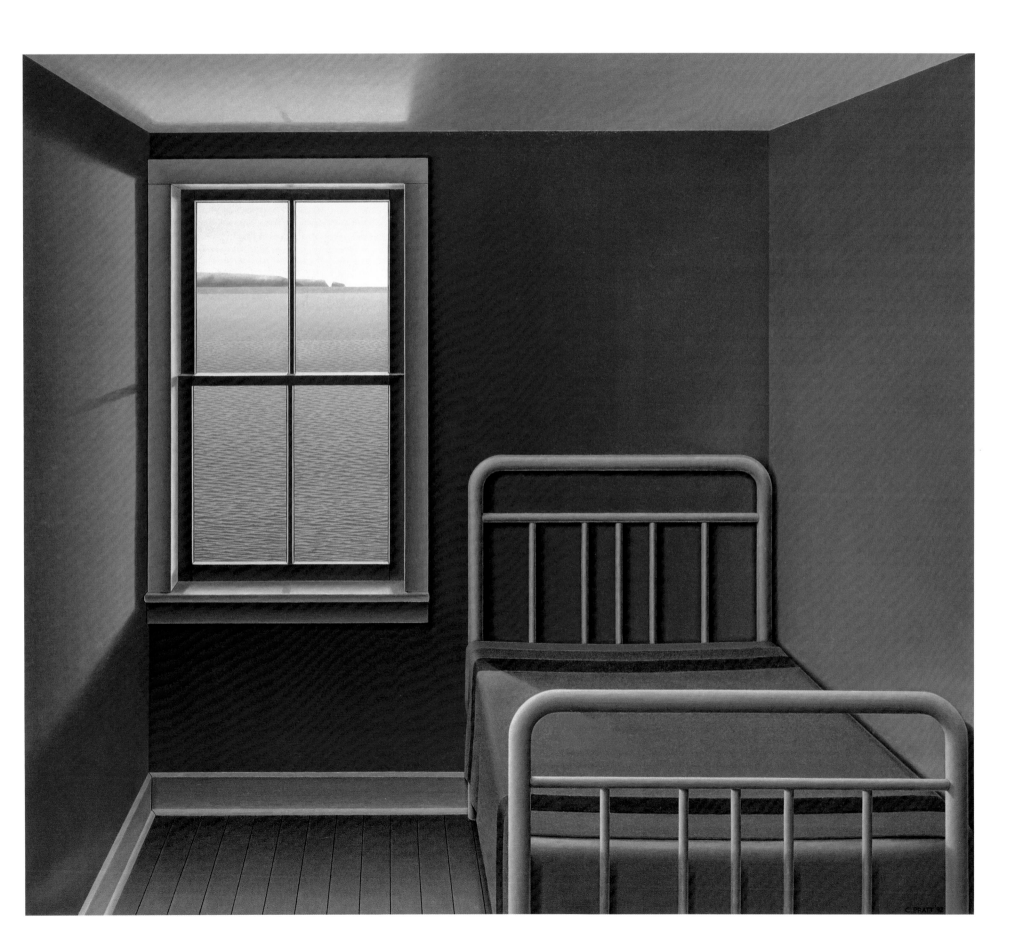

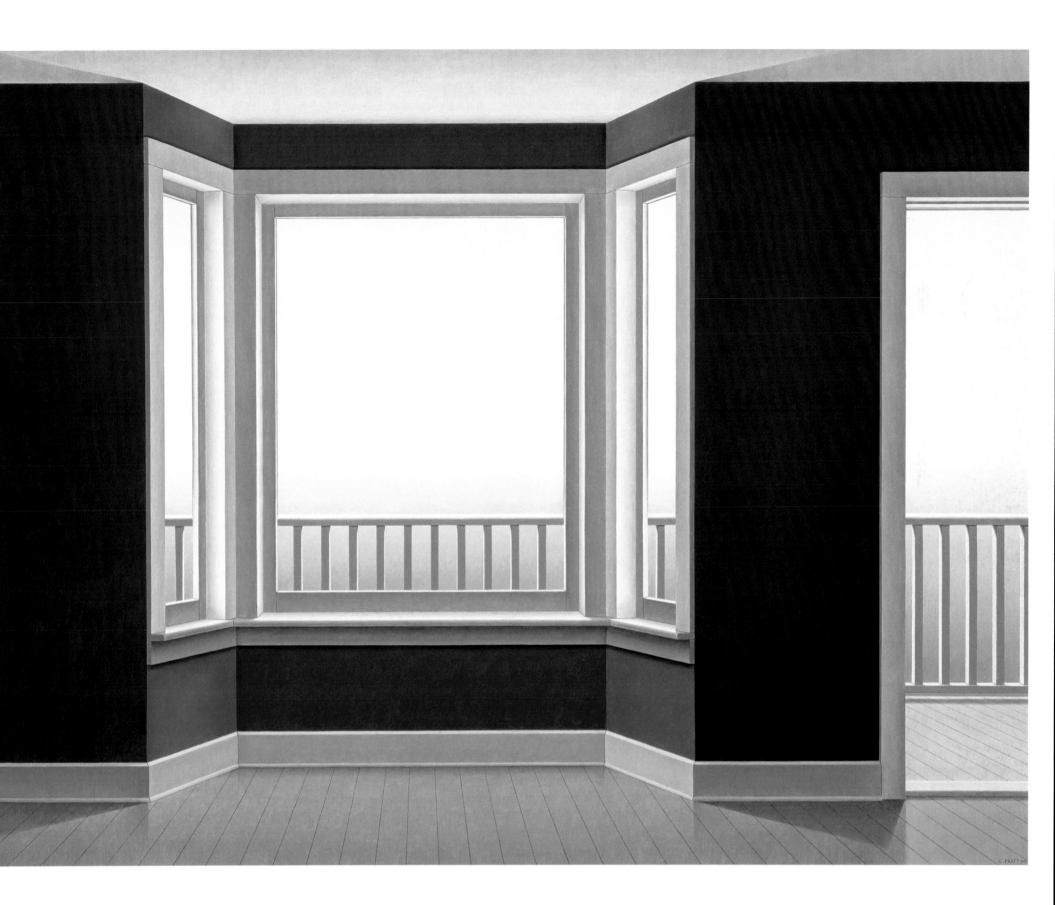

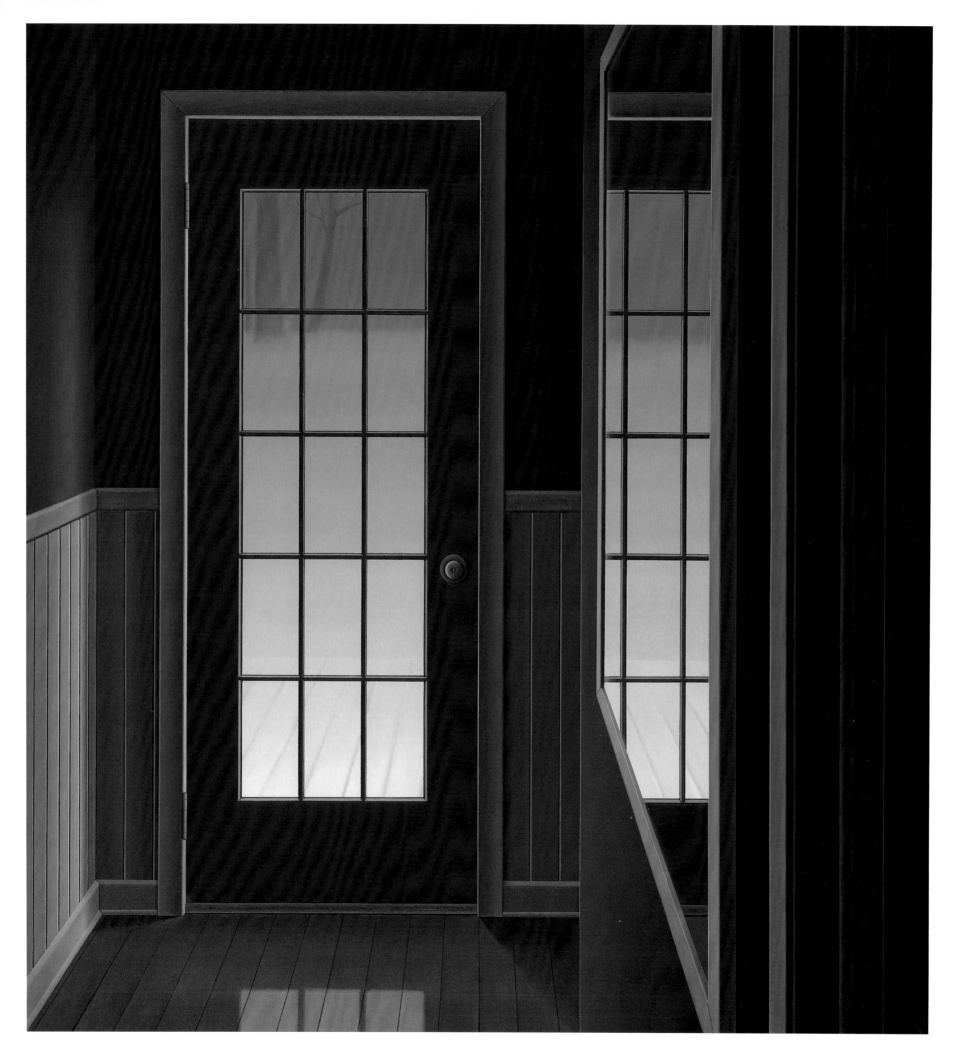

Reflections, windows, and doors are recurring motifs in Pratt's works, used to define and separate interior and exterior space. In many paintings – *Shop on an Island, Cottage* (1973, pp. 10–11), *Trunk* (1979–80, fig. 4), *Irish Point* (1989, p. 59), *A Room at St. Vincent's* (1992, p. 58), *Ferry Terminal* (1995, p. 30), *Storm on my Porch* (2002, p. 60) – windows and doors with window panes act as thresholds or barriers between inside and outside, framing and containing the exterior landscape, but also providing visual escape from often claustrophobic interior spaces. In other works – *Night Window* (1971, fig. 5), *Station* (1972, p. 13), *Subdivision, The Visitor* (1977, pp. 64–65), *Basement Flat* (1978, p. 17), *Basement with Two Beds* (1995, p. 63) – windows play a different role: instead of offering a view to the outside, they trap the viewer inside the represented space. In the two basement pictures, the windows offer only a limited view and a little light. In *The Visitor*, the blinds are completely drawn, and in *Night Window, Station,* and *Subdivision*, darkness turns glass panes into mirrors. Of *Night Window*, Pratt wrote: "A night window is a corruption: something that is meant to admit light and let you see out becomes a reflection of your room, of what you already know."[32] Its effect is disturbing and somewhat perverse, as the anticipated view is interrupted and the represented space seems to collapse on itself.

32
Pratt 1995, 63.

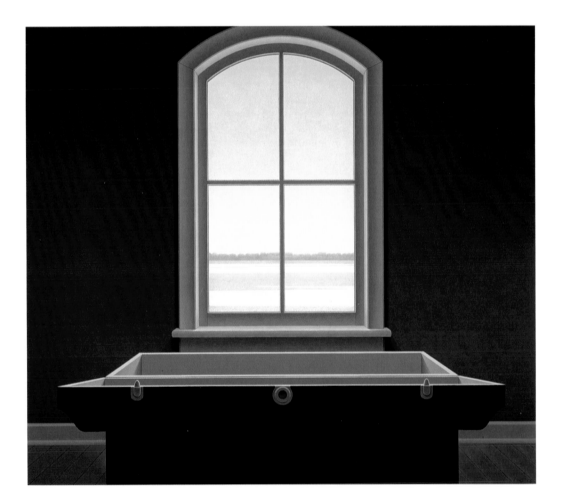

Fig. 4
Trunk, 1979–80.
Oil on board, 92.7 × 106.7 cm.
Private collection

Fig. 5
Night Window, 1971.
Oil on board, 115.6 × 75.6 cm.
York University, Toronto

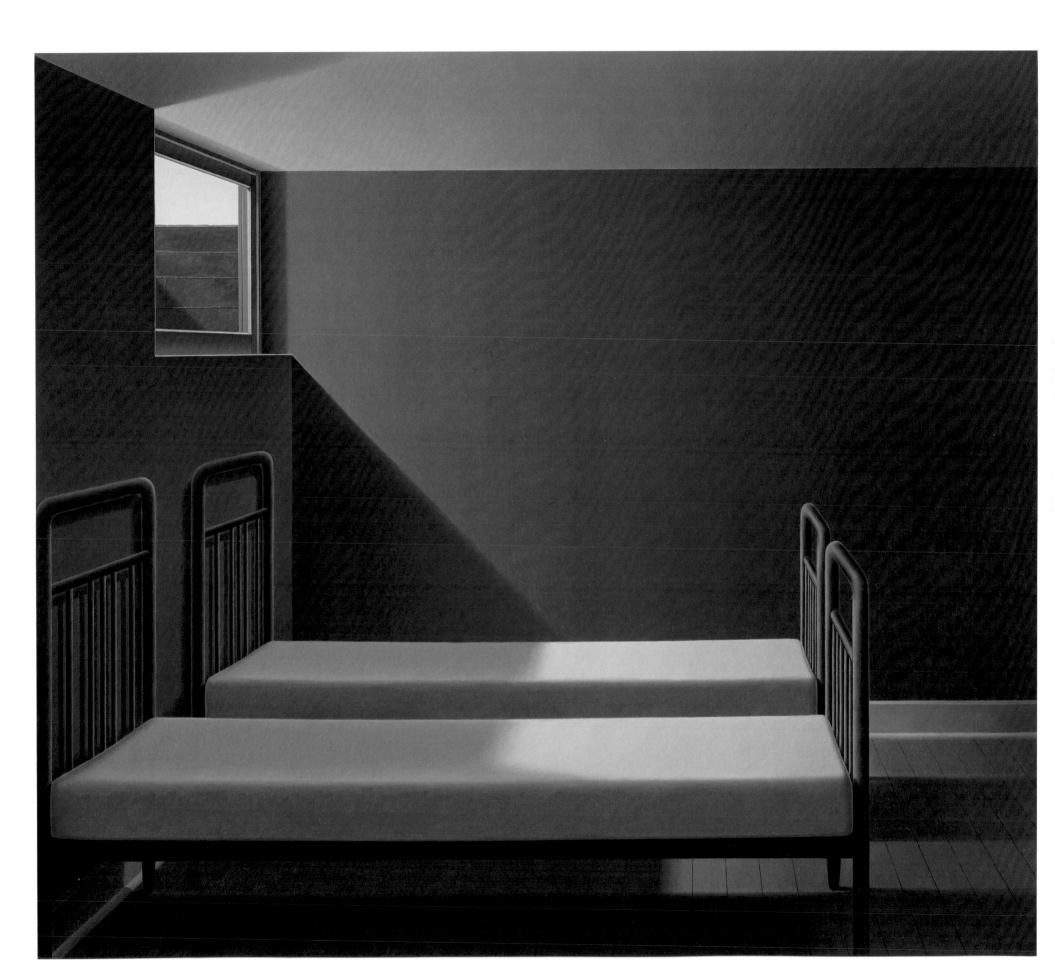

33
Pratt, written communication.

34
Pratt 1995, 171.

35
Wright, 95.

36
Alexander Wilson, *The Culture of Nature: North American Landscape from Disney to the Exxon Valdez.* (Toronto: Between the Lines, 1991): 30.

The window continues to be an important subject in Pratt's recent production. *Half Moon and Bright Stars: My Bedroom in September* (2001, p. 67) and *Love in Late Summer* (2002, fig. 6) depict the same three-panel bedroom window in Pratt's home on the Salmonier River, at different times of the day and to different effect. In *Half Moon and Bright Stars*, the window frames a nighttime view of the picturesque landscape, with fog rising from the tree-lined water. The foot of the bed defines the interior space and is echoed by the top of the balcony rail outside. *Love in Late Summer* uses the same composition, including the open window at the right, but in this daytime version the blinds are drawn and almost completely obstruct the view. Where the window in *Half Moon and Bright Stars* acts as a framing device for the landscape, in *Love in Late Summer* it becomes an object unto itself, right down to the blinds, window handles, and details of moulding omitted from the other work. Offering but a glimpse of the outdoors, *Love in Late Summer* refers more to interior space; Pratt says it is "about being 'in' the room."[33] The mood and atmosphere are also quite different; *Half Moon and Bright Stars* has an air of openness and mystery, while *Love in Late Summer* suggests privacy and intimacy. Although we usually think of windows as transparent, revealing an exact view of things as they are, Pratt's paintings remind us that windows are objects that divide, frame, and ultimately affect how we see the world. Where Alberti advised Renaissance artists to treat the picture plane like a window, Pratt complicates this relationship by insisting that we consider how windows may alternately reveal, reflect, or blind us to our perceptions.

Fig. 6
Love in Late Summer, 2002.
Oil on canvas, 146 × 177.8 cm.
Private collection

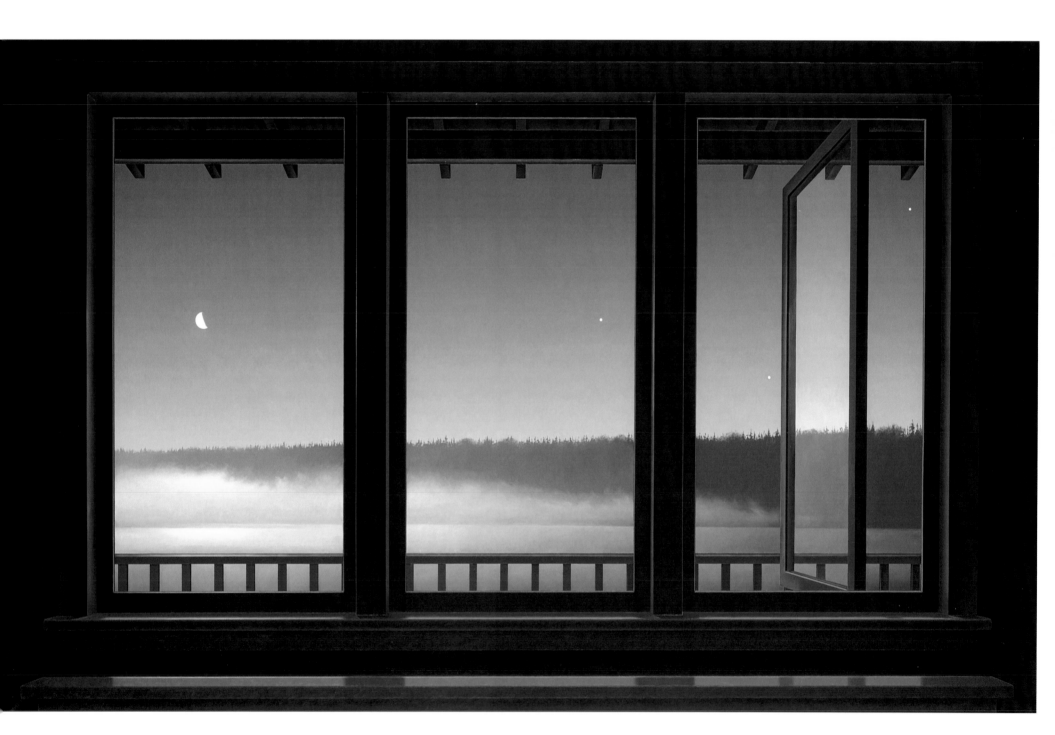

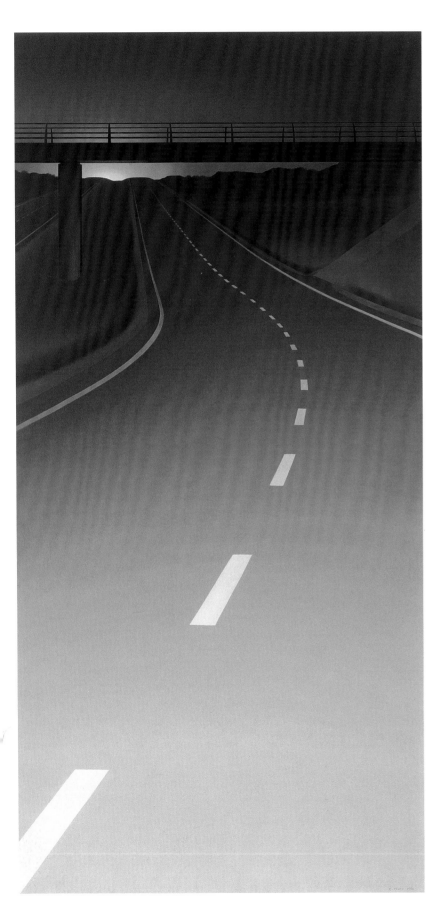

A different manifestation of the window appears in Pratt's recent work, in the form of the car windshield. In *Black Pickup* (1990, p. 69), the windshield of a parked truck functions as a static frame for a view of the ocean. In other road paintings the emphasis shifts from the object – the car – to the experience of driving. Even the frame of the windshield disappears, leaving simply the view of the road and surroundings from the vehicle. What we see varies: a dark landscape and the glowing headlights of an oncoming car in *Witless Bay Overpass* (1996, p. 68) and *Night Road* (1988, pp. 28–29); drifting snow from a blizzard in *White-Out at Witless Bay Overpass* (1996, pp. 32–33); and roads at dusk that lead to the evening star in *Driving to Venus: From Eddies Cove East* (2000, pp. 70–71), *Driving to Venus: On the Burgeo Road* (2000, pp. 72–73), and *Driving to Venus: A Long and Winding Road* (2001, p. 74). Although their settings differ, these paintings all describe moments or events experienced while driving. Pratt recalled the specific one that informed *Night Road*:

> We drove all the way from Corner Brook, nearly 500 miles, through an indigo-black night with high winds and mist blowing off the lakes and marshes. We had to watch for moose, and in fact we had one close call, but we made fast steady time. There was very little traffic, so when we did meet something it was an incident, and we were, in a modern way, like "ships that pass in the night." I enjoyed it very much: few things are as time-out-of-life as driving – it is my way of avoiding things, of being neither here nor there. Sometimes I think I could drive forever.[34]

Perception plays an important role in these paintings, as visibility is compromised by weather or darkness. The car headlights lead us into the unknown, where something is waiting to happen, something that could be disastrous. *Moose and Transports* (1993, p. 90) represents precisely this kind of haunting moment, right before an oncoming truck hits a moose.

The often tense relationship between nature and culture evident in much of Pratt's work is epitomized in his road paintings, as animals and the landscape are confronted with human devices: signs, fence posts, highways, cars, and trucks. Even natural light seems to compete with headlights. North Americans' relationships with the natural world have changed significantly in the twentieth century with the development of roads and cars. In post-Confederation Newfoundland and Labrador, the new provincial government invested heavily in transportation and communications. Roads would link rural communities both physically and culturally to other parts of Newfoundland and to the rest of the continent; they became an alternative to travelling by boat along the coast of the island, encouraging exploration of the province's interior. According to Miriam Wright, in Newfoundland the construction of roads and the growing presence of radio and later, television, "would play a large role in transforming popular culture, leading to changes in entertainment, local customs and even to local dialects and speech patterns."[35] The new highways would also contribute to the development of tourism. Horticulturalist and journalist Alexander Wilson observes that roads in general "were talked about as though they had an important democratizing role: the idea was that modern highways allowed more people to appreciate the wonders of nature."[36] Moreover, the car itself has changed our perception of the landscape: "The car imposed a horizontal quality on the landscape as well as architecture. The faster we

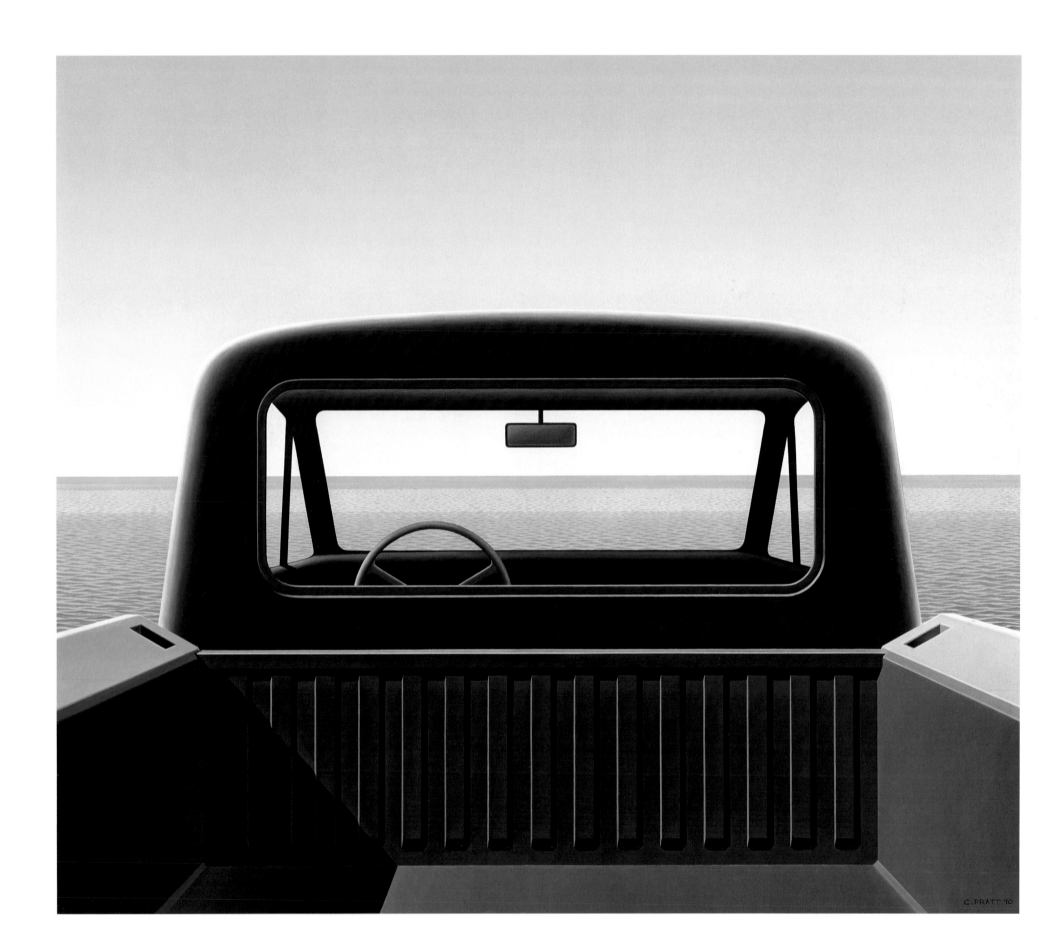

Driving to Venus: From Eddies Cove East 2000

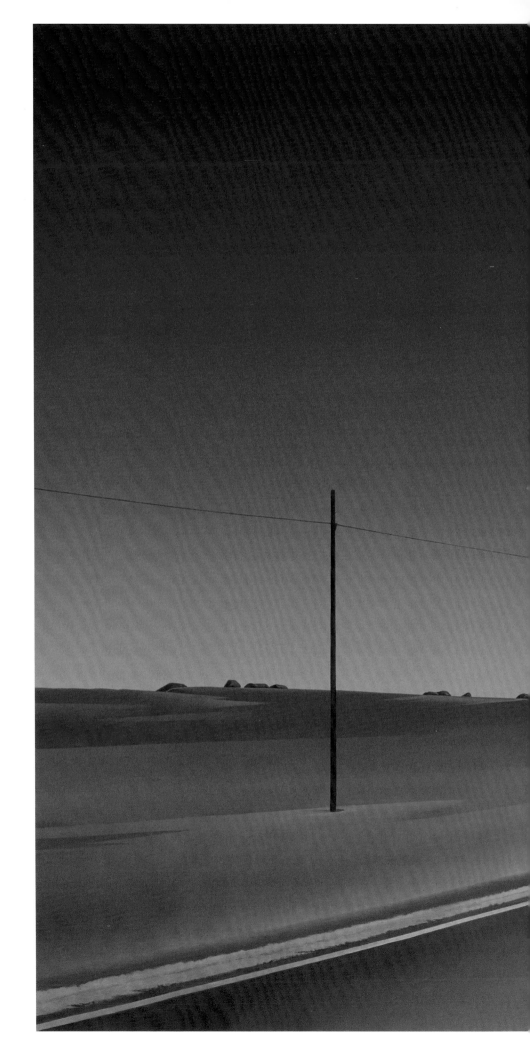

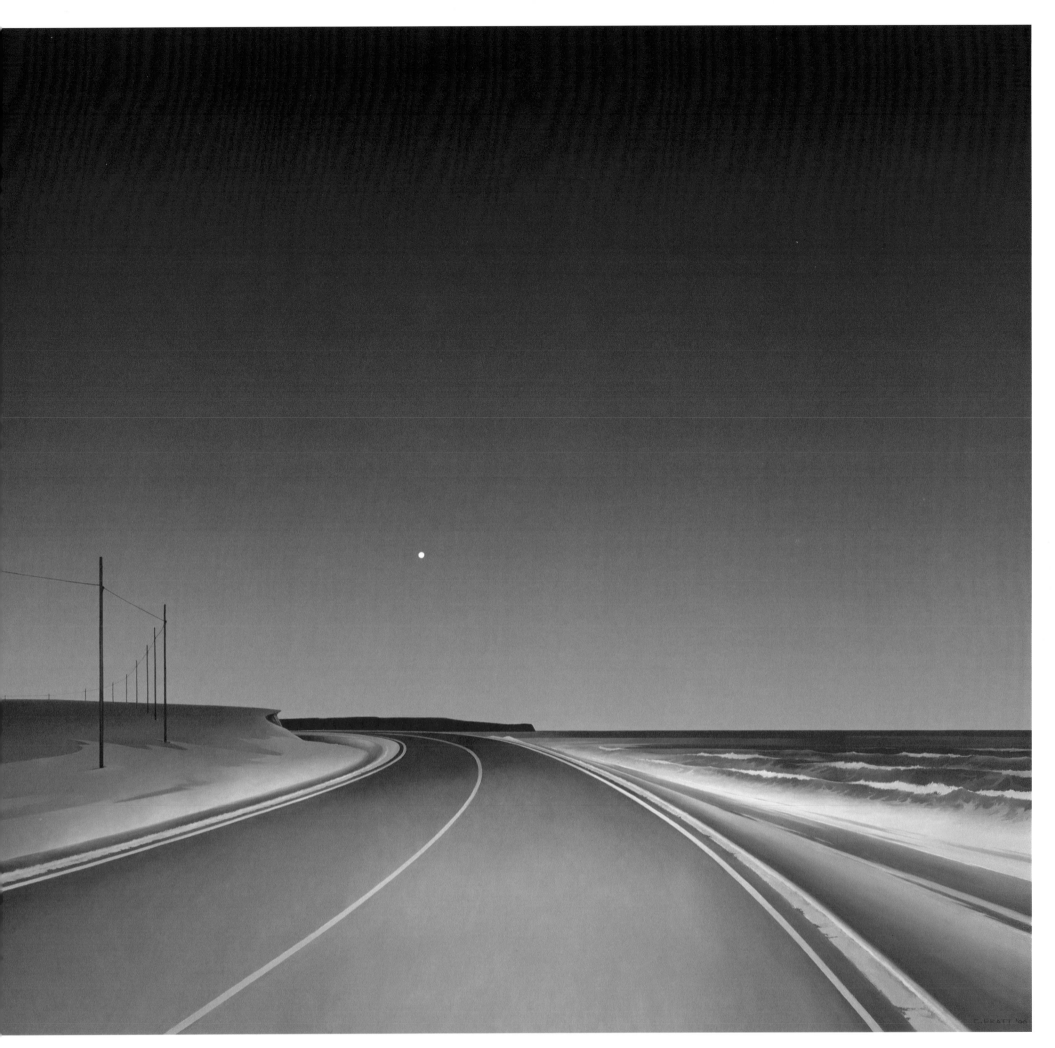

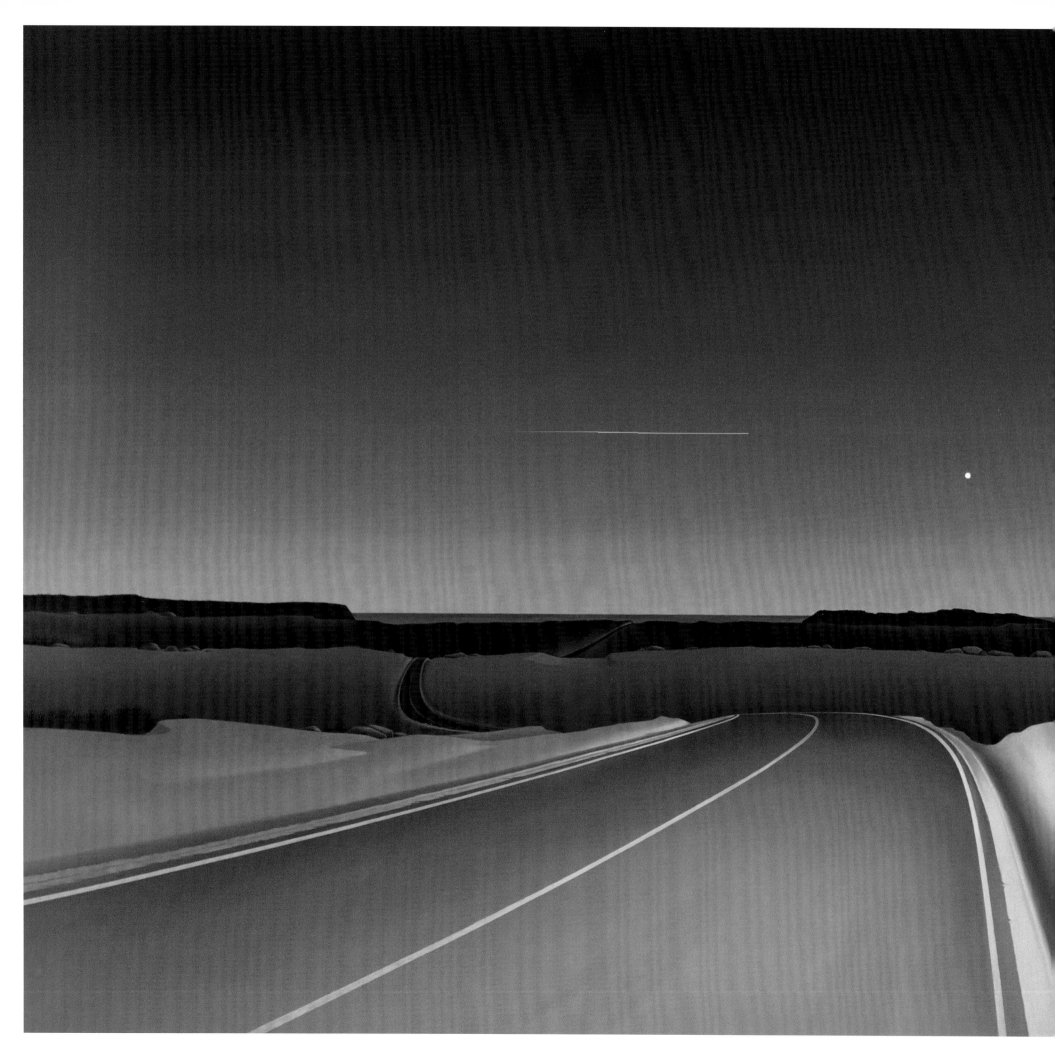

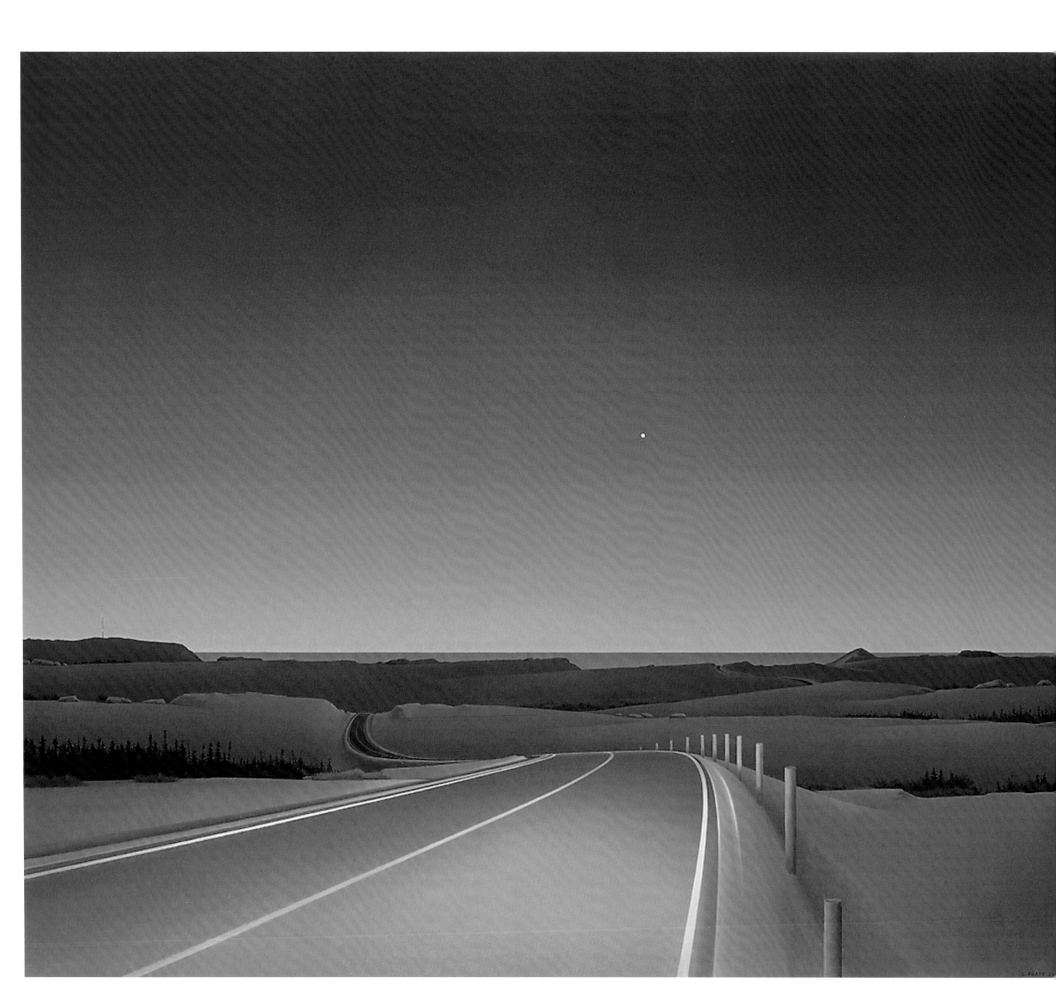

Driving to Venus: From Eddies Cove
East (working study) 2000

Study for *"Driving to Venus"* 2000

Study for *"Driving to Venus"*
(preliminary study 10) 2000

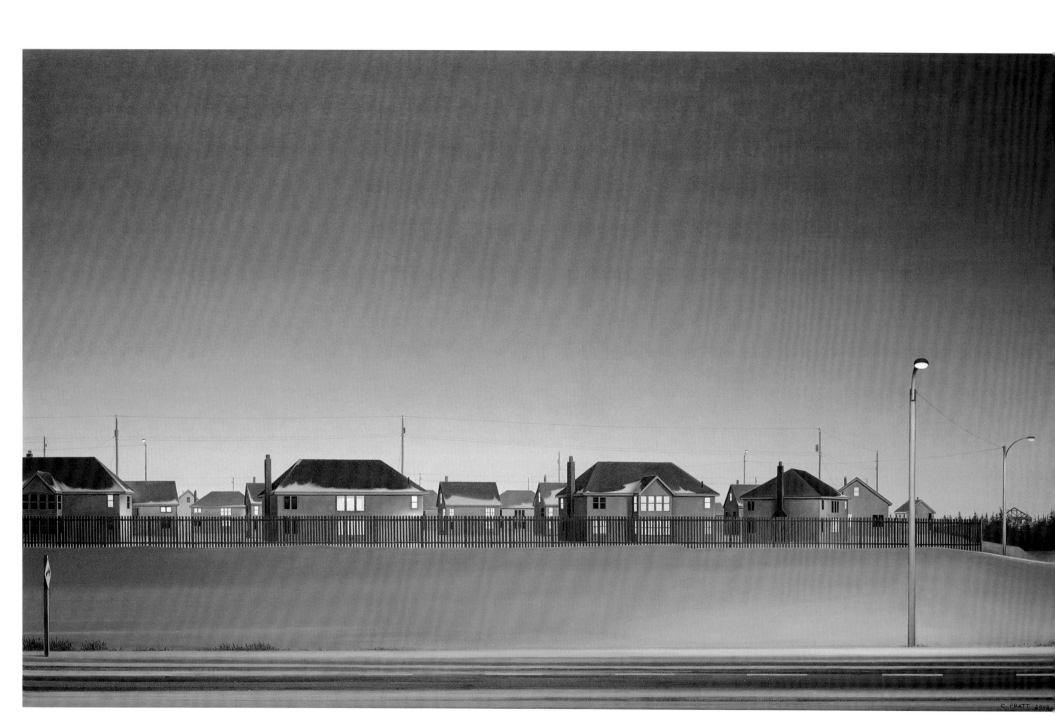

drive, the flatter the earth looks: overpasses and cloverleaf interchanges are almost two-dimensional when seen from the car window. They are events in automotive time."[37]

In Pratt's road paintings, signs, fence posts, and overpasses become markers – in Wilson's terms, events in automotive time – while the landscape seems largely unchanged. Of course, the landscape *is* changing as our highways, suburban sprawl, and exploitation of natural resources have a profound effect on nature. As much as certain roads have been designed to heighten our appreciation of the landscape by way of winding curves and breathtaking vistas, they have also altered and even destroyed much of the natural world.

Since the 1960s our reliance on cars has led in particular to the rapid growth of a relatively new form of human settlement – the suburb – in Newfoundland and across North America. Wilson explains the homogenizing effect: "A suburban housing development cannot pretend to look like the farm, or marsh, or forest it has replaced (and often been named after), for that would not correspond to popular ideas of progress and modernity, ideas based more on erasing a sense of locale than on working with it."[38] In *Suburbs Standing West* (2002, p. 76) Pratt emphasizes the tension between new houses and the landscape that has been cleared and divided to accommodate them. Light emanating from windows and lamp posts competes with the glow of dusk, while the housing development itself seems uncomfortable in its setting, constrained by the fence and power lines that create subtle visual barriers between homes, ground, and sky. In the foreground lies the ubiquitous road, alluding to the advances in modern transportation that have made suburbs possible. Only a forest beyond the limits of the development suggests how the landscape may have looked before humans intervened.

The theme of the changing landscape and the contrast between the natural and the built environment may be represented best in *Deer Lake: Junction Brook Memorial* (1999, pp. 80–81). In western Newfoundland in the 1920s, a hydroelectric power plant was established in Deer Lake when a dam was constructed at a once major river, the modestly

37
Wilson, 34.

38
Wilson, 91–92.

*The West Windows: Study for "Deer
Lake"* 1998

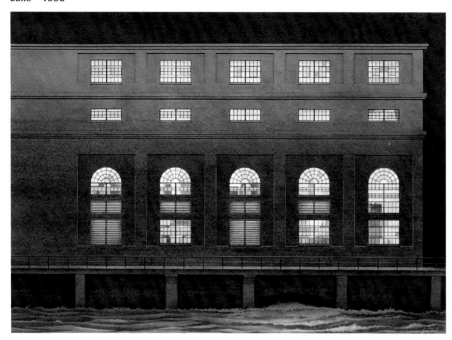

*Three Windows: Study for "Deer
Lake"* 1998

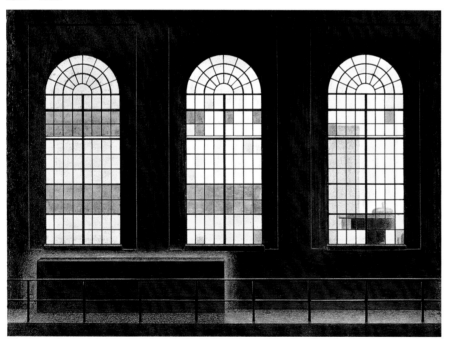

Window at Deer Lake 1998

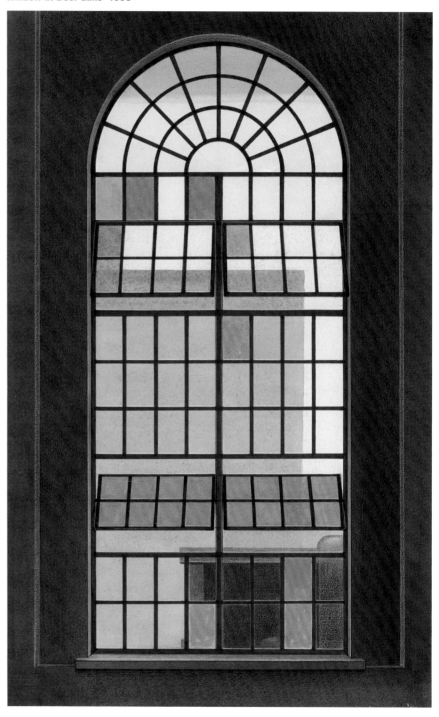

named Junction Brook. Pratt describes how the waters of Junction Brook have been affected by the dam: "Salmon still muzzle into the tails-race, still trying to access their ancient spawning grounds upstream, now dry for over 70 years; Junction Brook, now just a string of beaver gullies connected by trickles of water, is still posted as a salmon stream: "fly-fishing only" – a pretence that life still goes on."[39] In this instance, nature has not only been transformed by the construction of roads, but has been harnessed to serve humans through the production of electricity. Although the relationship between humans and nature is omnipresent in his work, with the exception of *Moose and Transports* Pratt had never before represented the two spheres in such conflict. Water in Pratt's paintings – in *Shop on an Island*, for example – is usually calm, serene, and suggestive of infinity. In *Deer Lake* it is raging.

Pratt explained that the painting "proceeded from that wonder we share at the immense power of water and then – at least for me – a kind of revulsion at its entrapment, imprisonment behind dams and containment in pen stocks and the fury of its release, like a wild horse breaking the gates, and the historical appropriateness of the concept of 'horsepower.'"[40] Only the bridge railing represented in the foreground prevents the water from appearing to spill out of the painting, as it separates the viewer from the "implied chaos."[41] Like all of Pratt's buildings, the power station is presented from a frontal perspective. Set against the night sky, artificial light emanates from the powerhouse windows that seem, with their interspersed coloured panes, to be made of stained glass. Inside, the turbines can barely be deciphered. Outside, the power lines disappear into the night. *Deer Lake* can be interpreted paradoxically: as a celebration of human achievements and mastery over nature, and as an elegy to the disappearance of a river. While he was working on the painting, Pratt wrote: "I may call it 'Junction Brook Memorial' if I decide to be political. And actually, that says it all."[42]

Deer Lake alludes to other hydroelectric power developments that have affected Newfoundland and Labrador's geography and society. Among them, the Churchill Falls plant, developed in western Labrador in the 1960s, has been particularly controversial. Supporters of the project believed it would provide both "a world class source of hydroelectricity" and

39
Christopher Pratt, *Christopher Pratt at Mira Godard Gallery.* (Toronto: Mira Godard Gallery, 1999): 22. [Pratt 1999]

40
Pratt 1999, 22.

41
Pratt notes that the railing is part of the bridge on which a person would stand or a car would pass to see the structure as presented. Written communication.

42
Pratt 1999, 22.

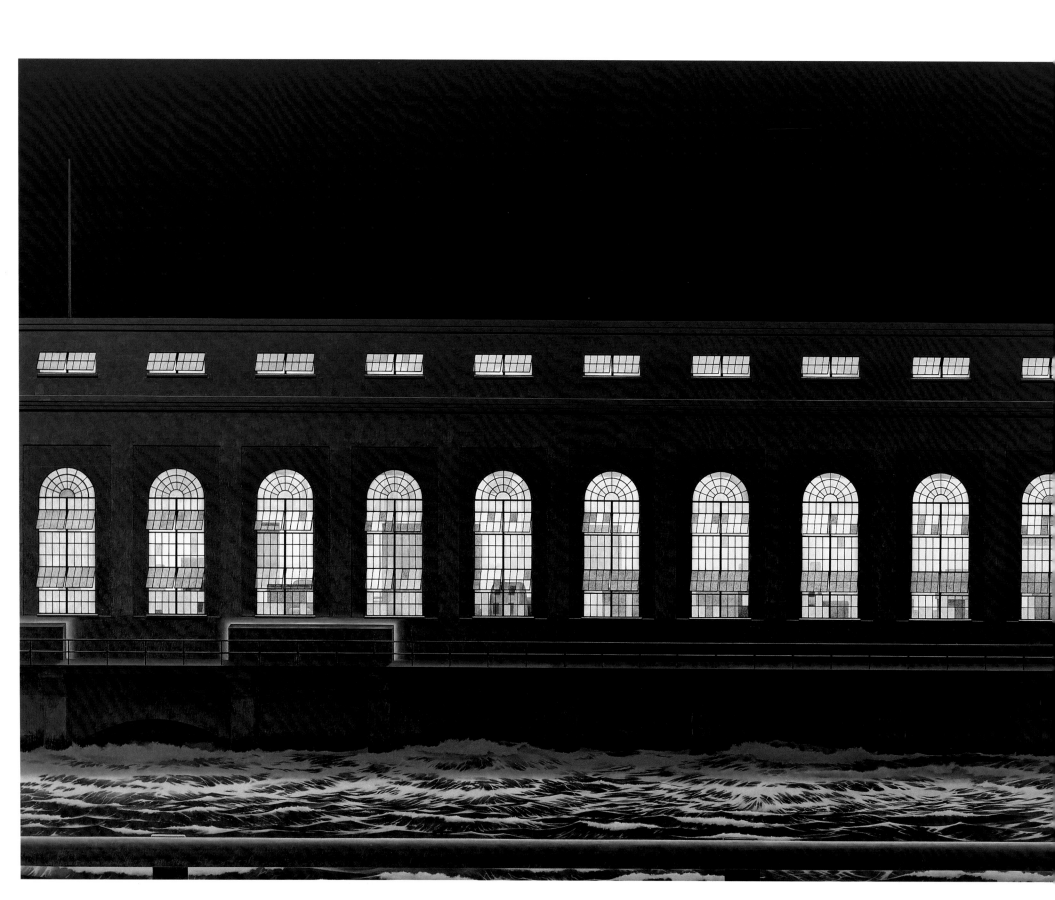

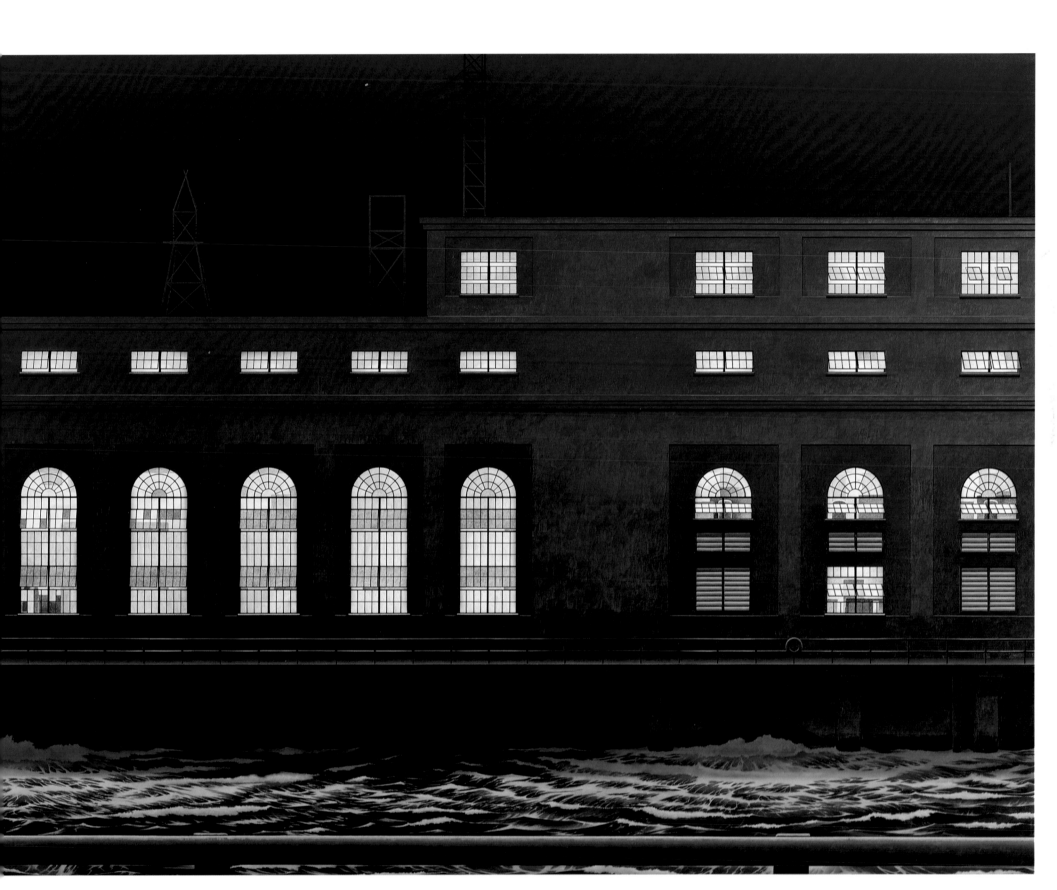

43
Churchill Falls (Labrador) Corporation,
"The History of Churchill Falls," *IEEE Canada*.
<http://ieee.ca/millennium/churchill/
cf_history.html> 26 April 2005.

44
Former Premier of Newfoundland and Labrador
Brian Tobin stated: "From 1976 to 1996, Hydro-
Québec received 96 per cent of the benefits,
while Newfoundland and Labrador got only 4
per cent." "Premier – Address on Churchill Falls
to Empire Club, Toronto," 19 November 1996.
Government of Newfoundland and Labrador.
<http://www.releases.gov.nl.ca/releases/1996/
exec/1119n06.htm> 10 March 2005.

economic benefit for the region.[43] To get Churchill Falls power to potential markets in central and western Canada, though, it had to travel across the Quebec power grid. For six years the Quebec government refused to allow it free movement, until a controversial agreement was reached in 1969 whereby Hydro-Québec would become Churchill Falls' only customer. It would also effectively control the export price of the electricity, yielding large benefits for Quebec and small benefits for Newfoundland and Labrador.[44] The Churchill Falls agreement continues to feed the anger of many Newfoundlanders and Labradorians about how the region has been mistreated by the Canadian government, which in this instance could have intervened on its behalf.

The majority of Pratt's recent paintings, including *Deer Lake*, signal an important shift in his work: they reflect how the artist has become interested in using a direct approach, working less from his memory and more from his immediate experiences. Titles refer not only to particular locations but also to the time of year, objects depicted, or even the weather:

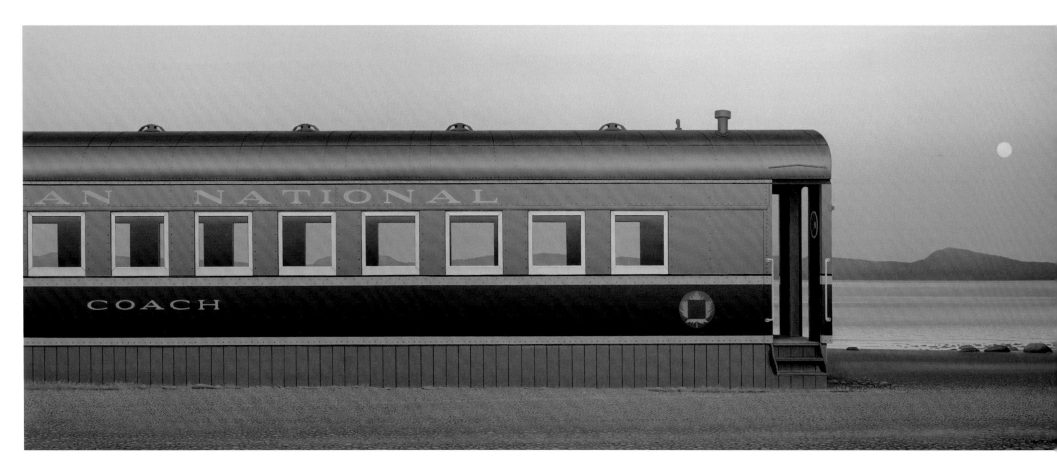

Witless Bay Overpass; *Argentia Bunker, August 1989*; *Benoit's Cove: Sheds in Winter* (1998, p. 83); *Ferolle Point Light* (1998, p. 84); *A Blizzard at Boswarlos* (2001, p. 85); *Railcar Camper Twilight at Peter Stride's Lake* (2001, p. 82); *Bear Cove, on the Strait of Belle Isle* (2003, p. 86); and *East Bay, Port au Port Bay* (2003, p. 87). Increasingly specific, they evoke qualities of the artist's experience, which becomes for the viewer, in turn, that much more vivid. The impetus behind this change has been twofold: certain events over the last two decades have affected the artist, and actual places and situations (as opposed to ones recalled or imagined) have become more significant to him. Among the pivotal events, seeing his 1985 retrospective exhibition, curated by Joyce Zemans for the Vancouver Art Gallery, resulted in his desire to work bigger and faster. A 1992 fire that destroyed his studio and a 1994 flood that damaged a good part of his production were both traumatic experiences, but Pratt explained the positive result: "I dusted off some very old ideas and worked on them, by way of 'touching base.' I ignored thirty years of acquired constraints."[45]

45
Pratt 1995, 190. The artist is referring here specifically to the consequences of the fire.

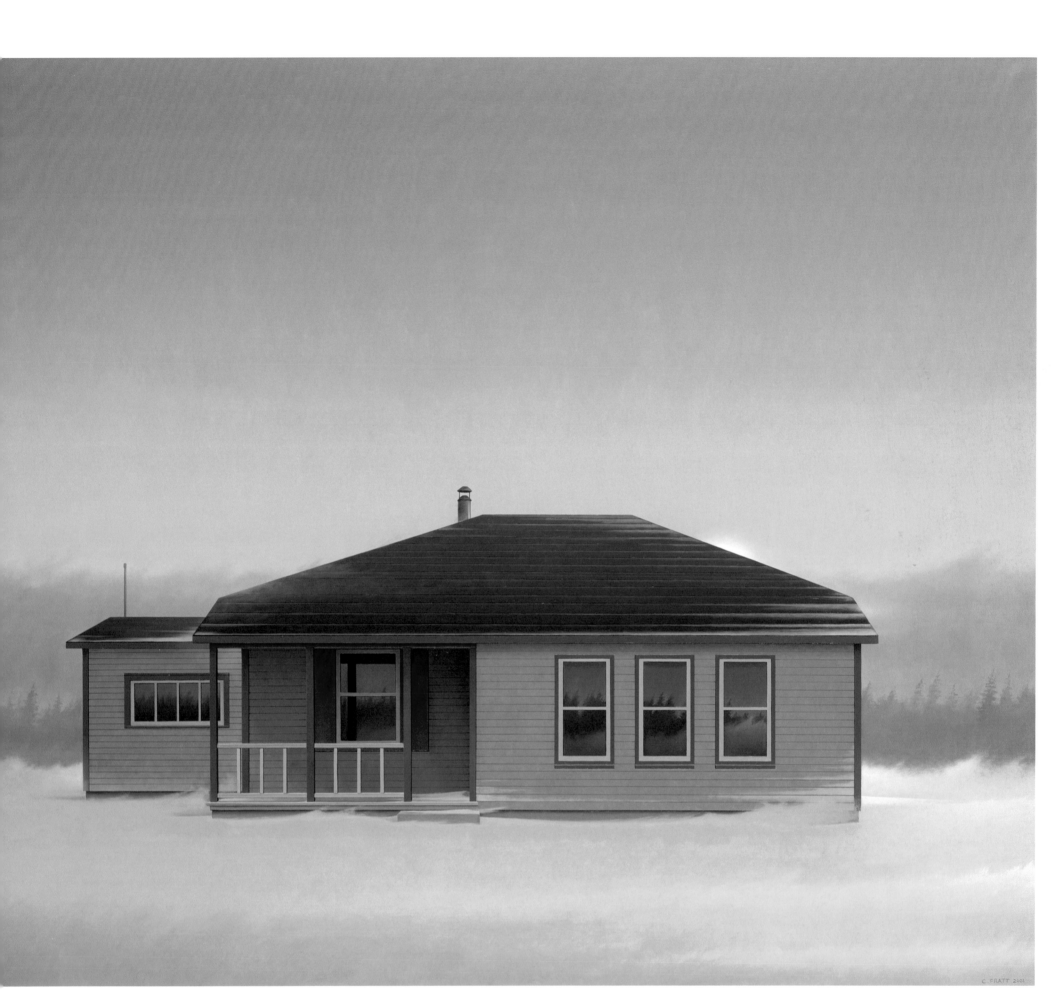

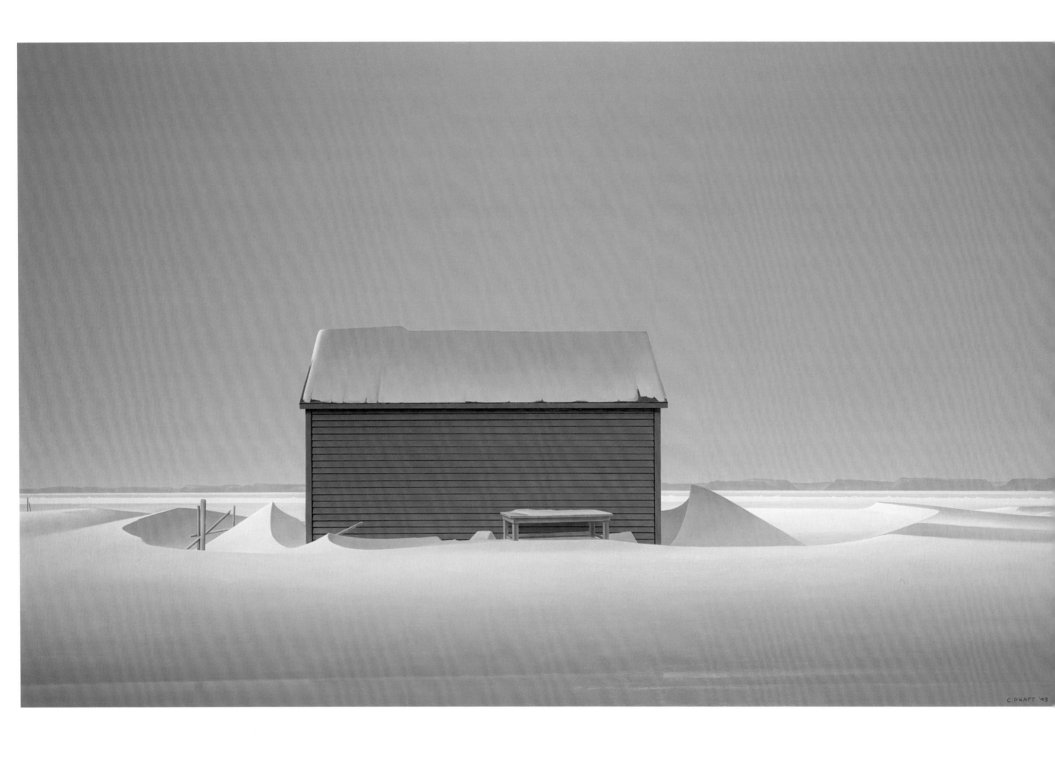

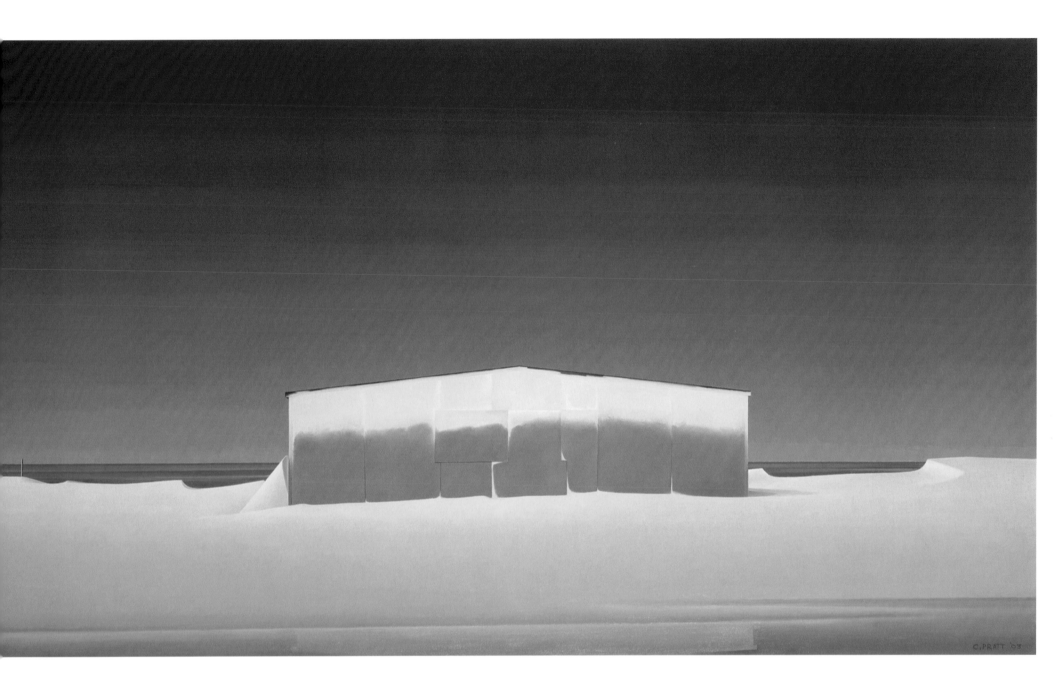

Study #1, "Winter at Whiteway"
2003

Study (Sunset), "Winter at
Whiteway" **2003**

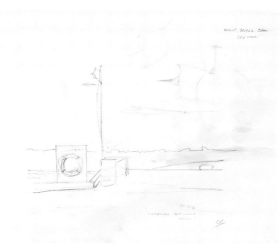

Study #2, "Winter at Whiteway"
2003

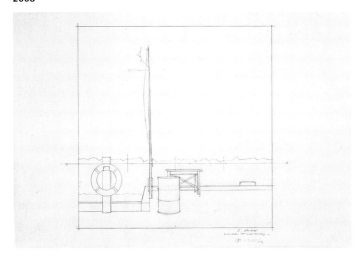

Study, "Winter at Whiteway" **2003**

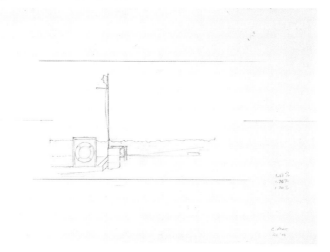

Study #3, "Winter at Whiteway"
2003

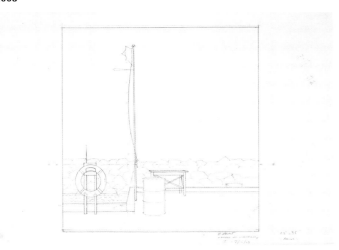

Based on a February 2003 visit to the community of Whiteway in Trinity Bay, *Winter at Whiteway* (2004, p. 37) exemplifies the shift in Pratt's work. On a snow-covered wharf – a federal government Department of Works structure – a flagpole bears the last remnants of a tattered, neglected Canadian flag. An oil drum and a table used for splitting cod stand below the flag, while behind an ice-covered breakwater, the sun sets on the scene. Of this painting, which may be Pratt's most political piece to date, the artist wrote:

> I actually saw a flag that had been torn and shredded and achieved the shapes of the one depicted here. The table in the background is the kind of table that was used for splitting codfish before the moratorium; the oil drum in the foreground should now speak for itself. All these elements were present in that place on a February afternoon when I was there, more or less in the configuration in which they appear in the painting… It may sound rhetorical, but it seems to be a perfect analogy for Newfoundland's current situation as a province of Canada.[46]

Winter at Whiteway not only comments on Newfoundland as Pratt saw it then; in light of later developments surrounding the Canada-Newfoundland Atlantic Accord, the painting seems almost prophetic. In December 2004, Newfoundland and Labrador Premier Danny Williams ordered that all Canadian flags on provincial government buildings be removed, in response to a federal government offshore revenue sharing plan he called a "slap in the face." Earlier, in 1985, the Government of Canada and the Government of Newfoundland and Labrador had negotiated an agreement on the management and revenue sharing of offshore oil and gas resources; under the Atlantic Accord, the province would be the primary beneficiary of the resources, gradually end its reliance on federal transfer payments, and become a self-sufficient province within Confederation. By 2000, Canada had met its main goal of the agreement to achieve national self-sufficiency in oil and gas resources. As of 2003, though, the province remained the minor beneficiary: after transfer payment reductions, the federal government received eighty-eight percent of the offshore revenues, while Newfoundland and Labrador received only twelve percent.[47] In 2004, during ongoing negotiations of the agreement, and after a campaign promise by Prime Minister Paul Martin that the province would keep one hundred percent of the revenues, Premier Williams used the flag to visibly protest the new offer and the federal government's general mistreatment of the province. A national uproar ensued as Canadians debated the legacy of the Atlantic Accord, the merits of Premier Williams' actions, and the meanings of the flag for everyone. For his part, in an interview on CBC Radio's *The Current*, Pratt supported the premier's order as an appropriate response to the prime minister's broken promise.[48] He would later write, "I'm not sure that the maple leaf has had time to acquire a common meaning in all parts of Canada. I think because of its use as a word mark, it is most directly associated with Government or Ottawa."[49] He believes this may in particular be the case for people who, like himself, were born before Confederation.[50]

46
Christopher Pratt, letter to Mira Godard, n.d.

47
Other provincial governments also profit from the revenues though the federal government. John C. Crosbie, "Overview Paper on the 1985 Canada-Newfoundland Atlantic Accord," *Royal Commission on Renewing and Strengthening Our Place in Canada*. Research Papers, March 2003: 266–70, 277. <http://www.exec.gov.nl.ca/royalcomm/research/pdf/Crosbie.pdf> 25 April 2005.

48
Christopher Pratt, interview by Anna Maria Tremonti, *The Current*, CBC Radio, 5 January 2005.

49
Christopher Pratt, letter to the author, 24 March 2005.

50
While Pratt does not set out to make political art as such, he is not the only contemporary artist who is critical of how the government has mismanaged resources or even mistreated peoples. Among artists who take up the subject of mistreatment, Robert Houle has been particularly critical of the tenuous relationship between First Nations peoples and the federal government.

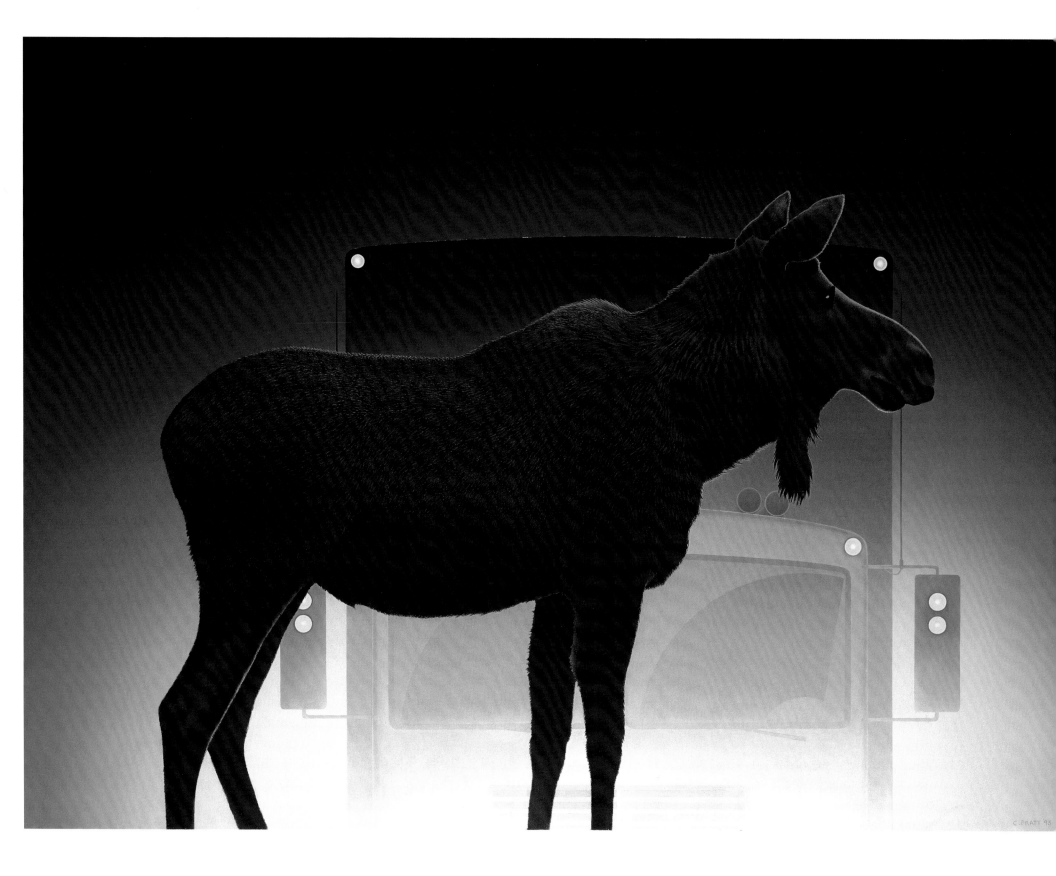

Through his art, Christopher Pratt shares his personal vision of Newfoundland – images that are informed by the grand narratives of the place and reflect concern for the kinds of political, social, cultural, and ecological changes that are occurring across the continent. Presenting us with abandoned structures, landed boats, and empty interiors on the one hand, and new highways, industrial buildings, and suburban developments on the other, Pratt's work urges us to reflect on our complex relationships to the world and consider how modernity and progress, effectively fashioned by the government, are transforming Newfoundland and Labrador, for better or for worse. Seen as memorials and even elegies, they honour Newfoundland's past, document the present, and caution us about the future.

Explaining how loss and hope, past and future relate for him, Pratt reminds us that vision is not only about what may be seen, but also what may be imagined:

> More than a vanishing way of life, it is myself I mourn for: the loss of part of my identity. I'm curious about Newfoundland's past, and proud of it. People who don't know where they've been or what they've been generally don't know where they're going or who they are. But at the same time I'm not so myopic as to believe that you can judge people by their past. I think you have to judge people by their aspirations.[51]

51
Pratt in Silcox 1982, 54.

LIFE IS NOT A REHEARSAL
Barbara Dytnerska Speaks with Christopher Pratt

For this exhibition, Christopher Pratt spoke with Barbara Dytnerska at the National Gallery of Canada about his life and work. The artist reflected on some of his major themes and formal concerns, and explained how his art continues to evolve today.

Barbara Dytnerska: *You have explained in the past that being born in Newfoundland and living most of your life there has had a significant impact on your work. Can you tell me a little about your formative years?*

Christopher Pratt: I was born in Newfoundland in 1935. I grew up and went to school in St. John's, first to Holloway School and then, from grade seven to matriculation, to Prince of Wales College. That was before Confederation. I was very much aware that Newfoundland is an island. I became very passionately attached to Newfoundland through stories I heard from my older relatives and places I visited. I was never off the Island until I went to Mount Allison University in 1953. My early paintings were a celebration of all of that, real and imagined.

What's it like to live in Newfoundland? What do you think of the environment?

Living in Newfoundland is actually very exotic in some ways. To me, in one word, it's wonderful. I actually like the weather. It can be everything from serene to violent, but it's always something, and always variable. It's like a stage set where the special effects person has gone bananas. It lives. It's not nearly as bad as it's made out to be! I like the fact that so much of the country is open. You can see for great distances across the Atlantic, but also across the land. There's absolutely nothing claustrophobic about it. I've had this relationship with the geography of Newfoundland as long as I can remember.

Living and working in a small community like Salmonier would be very different from working in, say, Toronto or Vancouver. How does the East Coast experience affect your approach to art?

There is something inherently stimulating in being away from what people consider to be "the mainstream." I have never been concerned with manifestos or the latest "ism" or what's happening in what is considered to be the mainstream of art. I'm aware of them, I take them into account, but in the end I'm not interested in them. They don't have anything to do with my day-to-day life, or impact on the sense of isolation that is important in much of my work.

People have drawn parallels between your work and other Canadian and international artists. Who would you say influenced you most?

Of the Canadian sources that are most commonly cited as influencing my work, the most prominent would be Alex Colville. But when I was at Mount Allison I had Lawren P. Harris as a teacher; not many people know his work as well as they should, but he had a strong influence on me. I was also attracted to the work of Jean Paul Lemieux and Lionel LeMoine Fitzgerald. Earlier on, growing up in Newfoundland before Confederation, we had American stuff and British stuff, so we had American magazines, and I was well aware of painters like Charles Sheeler, Winslow Homer, Edward Hopper, Thomas Eakins, the Ashcan school, the

Regionalists, and the Hudson River school, even Jackson Pollock and Mark Rothko, before I had even heard of the Group of Seven.

You mentioned Edward Hopper. What kinds of lessons did you draw from his work?

The first time I saw a painting by Hopper – I believe it was reproduced in *Life Magazine* and I'm pretty sure it was the painting *Early Sunday Morning* [fig. 7] – it resonated with me because there were places in St. John's that looked something like that, and it allowed me to understand something of the transition from reality into what we are pleased to call "Art." I could then understand the difference between a photograph of a place and a painting of that same place, although the Hopper image had some photographic aspects about it in terms of its realism. I could see what the difference was and what the transition had to be in terms of what I was doing myself, and that was very important to me. I had something of the same experience later when I went to Mount Allison and saw the difference between the reality of the Sackville area and Alex Colville's depiction of it.

Were you influenced by writers, as well?

Yes, and in the same respect. The only Canadian writer I knew much about was my uncle E.J. Pratt. I had heard of Robert Service, Bliss Carman, and Charles G.D. Roberts, but that was about it! My influences were American poets and writers – Robert Frost, Emily Dickinson, Carl Sandburg, John Steinbeck – the usual – and British poets. I was particularly interested in Thomas Hardy (I think because there was a photograph of him where he looked rather like my paternal grandfather, J.C. Pratt), A.E. Houseman, Gerard Manley Hopkins, and many others whose poetry I found visual – those people influenced me greatly. I haven't read widely in terms of novels or essays, but I could relate easily to Hemingway's Nick Adams stories, and later, *Lord of the Flies* and *The Bonfire of the Vanities* had considerable influence on me. I also learned a lot from books like Robert Ardrey's *The Territorial Imperative,* Dee Brown's *Bury My Heart at Wounded Knee,* and Roger Kahn's *The Boys of Summer.*

Architectural structures are your most complex and enduring theme. Is the function of buildings for you purely formal, or is there more to it than that?

My requirement for a kind of minimalism or abstraction in my work lends itself to representations of buildings, windows and things structural, but beyond that, buildings have a kind of personality for me which is more than narrative or anthropomorphic and very difficult for me to explain. I often wonder about it myself, I often search for explanations that I can provide for people, when they ask me, but those are questions the images themselves try to understand. Those "personalities" resonate with me; it's not something that tells a story, or their history – their past, present, or future. It has more to do with the way light falls on them, as subtle as hearing something barely audible and losing it just as it starts to make sense, to sort itself out. Most of the interiors I've painted "remember" incidents in my life in terms of where they happened. The "place" seems to package, almost encapsulate, the event, to preserve its essence. Often I don't remember exactly what the event was until the image is well along.

Fig. 7
Edward Hopper, *Early Sunday Morning,* 1930.
Oil on canvas, 89.4 × 153 cm.
Whitney Museum of American Art, New York.
Purchase, with funds from Gertrude Vanderbilt Whitney

Can you give me an example of this, of when the image itself has revealed the incident?

There's a painting, it's actually here in the National Gallery, called *Institution* [p. 95]. There were numerous studies for that painting and I didn't really know what I was doing, or where I was heading as I was doing those studies. When they finally got there I recognized after the fact that it was the view from the room, or rather was based on the room, at the Grace Hospital in St. John's where I had had my appendix out when I was sixteen and – not to be morbid or prophetic or anything about it – the same room where my father died twenty-eight years later. Those things are not connected except by coincidence and the power of association.

Why are the interiors in your pictures always so empty?

That's a difficult question because I don't find them empty. The spaces aren't empty because I am there…I am alone, a ghost. I'm not sure why they're devoid of texture and furnishings – I think it goes back to experiences in my childhood – not to be excessively Freudian. My childhood was in no way barren or cold, my parents weren't indifferent, and yet I had a sense of loneliness about it. I remember those places, those "rooms," as spaces, and the details of furnishings don't seem to matter. The feeling I have for the space has little to do with whether there was a lamp in this corner, or a ragged chair in that corner, or a trophy or a bowl of flowers somewhere else. It's the sense of the space itself, the enclosure. It became a private space, I suppose you could say again, a lonely space. And actually we didn't have a whole lot of furniture and no pictures when I was a child.

The boat is another major theme in your work. What have boats meant to you personally?

I always wanted to have a boat. Of course, we puttered around in row boats, flats, and punts, fishing on ponds, but living in St. John's denied me access to what I thought of as being a rite of passage when I was a boy – the opportunity and ability to be part of a crew putting to sea. I would hear people talking – my uncles when we visited them in Bay Roberts, and people we met at places where we boarded at Southeast Placentia and Trepassey – about boys who had "skippered their father's schooner to 'the Labrador' when they were only 15 years old." Boats symbolized the essence of Newfoundland and Labrador. It seemed to me they were more important as a way of getting back to the Island than escaping it…I bought a boat long before I could actually afford it…and I still have a fibreglass sailboat. I don't sail as much as I used to, but I still love it.

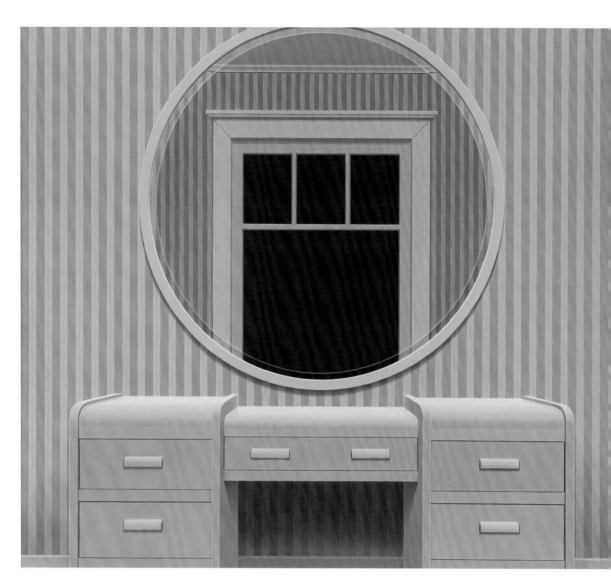

In the late 1980s you developed a new theme in the road paintings. How did driving turn into art?

I like driving. I like the hum of the tires, I like the sense of the car going across the countryside. I like the privacy of being in the vehicle and the fact that you can't possibly do anything other than listen to your music and watch the world go by. You can't berate yourself for not being in your studio because you're nowhere near your studio. So the world goes by and I encounter things that really appeal to me, things that sing. Often they're not there if you stop the car: the motion was a defining and essential part of the experience. I was driving back to Salmonier from St. John's one evening and I was going across the Hawke Hills, a very beautiful, very barren area, and driving into the sunset. (Some people think that the sunset colours in some of my paintings are absolutely lurid and that's because they haven't been in Newfoundland and seen the sunsets here.) The sun had just gone down, and right in front of me was this bright pinpoint in the sky and it was Venus in its role as the evening star, and in a romantic, illogical flurry of joy I thought, "Hell, I'm driving to Venus!" and then I immediately thought, "Well, this is a great title for a painting." I went home and started thinking about roads and how the roads wound ahead of me with this pinpoint planet as a destination, and I worked on it and came up with ten or twelve versions of it, and I finally did paintings of three of them. I enjoyed doing all of them. In each case I imagined myself on a specific road, and although the images are constructed from sketches and memory, I gave them titles to indicate that I had been in a specific place.

You are as well known for your prints as for your paintings. Does a print ever evolve into a painting, or vice versa?

There's a relationship between the imagery in my silkscreen prints and my paintings, but I never did a silkscreen print that was in anyway a 'reproduction' of a pre-existing painting. At some point in the development of an image, when it had passed the preliminary stage, I would decide whether it should be a painting or a print (or not happen at all because it just didn't cut it). I made those decisions on the basis of how the image was coming along. They were usually intuitive and obvious…I stopped making silkscreen prints in 1997 for health reasons, and come to think of it, my paintings have become increasingly complex since then. But there are many reasons for that.

You've described painting as a joyous experience. Can you talk a little about that?

I just like being in my studio…I like lots of other things but I like painting as much as anything, and there are times I like not doing anything at all. I just want to "be." There is such a thing as laziness, but I think there is merit in just "being." Somehow or other the greatest gift we have is the gift of our own consciousness, and that is worth savouring. Just to be in a place that's so silent that you can hear the blood going through your arteries and be aware of your own existence, that you are matter that knows it is matter, and that this is the ultimate miracle. When I get up at around 5:30 in the morning and it's not yet daylight if it's in the winter, it's always wonderful to go into my studio and turn up the heat. I like the promise that maybe I'll do better that day than I did the day before.

What about the painting process itself?

Painting can be very tedious, the way I work – you know, week after week after week, filling it in, filling it in – doing a painting the size of *Deer Lake: Junction Brook Memorial* [pp. 80–81] with a number eight flat or a number one round sable brush. You'd never set out to paint a wall like that. I'm not a gestural painter. I don't do the Jackson Pollock or the Vincent Van Gogh thing, or paint expressively, if by painting expressively you mean painting from the ankles or the shoulder or the elbow. I do a kind of shuffle, a dance as I approach and retreat from the canvas, and I paint with my fingertips. I sort of caress the paint onto the surface. It's the point of connection between the idea and its realization. If it were electricity it would spark. I like taking a dark area and a light area or a warm colour and a light colour and blending, working them together. It becomes very sensuous. Even the thinnest layer of oil paint has an edge, and there is a satisfaction in bringing that edge up against another edge – just letting them touch. Sometimes I work on a painting for a month, or three months, and then I look at it and it's "done" and I have thirty seconds of satisfaction, even joy, that it's done, followed by days of doubt – doubt that it's alright but hey, it's done and that's it. And people ask, "Do you mind parting with them?" and I answer honestly, "No, it's my living." I would mind more not parting with them. I would rather take that thirty seconds of satisfaction and send them off and then start again. It's been my life and a very good life and it will be my life until I'm put in a container of some kind. I'm not leaving here on foot.

When people talk about your work, they usually focus on such aspects as its geometry, precision, and simplicity. What would you say is the most important formal element in your art?

The most important thing in my work is light. Composition and design are important elements in any two-dimensional art, but in mine they are the bones, and light is the flesh and blood. It is the essential metaphor for life, even when it is an artificial light we contrive ourselves. It can be full of movement, promise, optimism, despair, hopelessness…The way light falls on a building or fills a room is more important than the place itself. The place is the stage and the light is the play. By extension, the absence of light has a mood about it as well. There is an opportunity to depict a different kind of light in the night images – artificial light – or, for example, the contrast between the light from the headlights of a car and light remaining in the sky. When I'm trying to decide whether a painting is finished, if the light isn't "right" I may spend weeks just glazing in lights and darks, building up contrasts, heightening and adjusting things, tuning them so that the light "does it." When I decide I've gotten there, then I have that thirty-second rush.

What about your treatment of space?

The use of perspective and rendering of light to create an illusion of the third dimension is important in some images but not all. I think that a painting has to admit to and respect its two-dimensionality, even when the illusion of space is necessary. But the absence or denial of space can be very powerful. In the painting *March Night* [pp. 14–15], the wall of the house is right there and you're smack up against it. The only relief is that you can go around the corner and there's this deeper space, but you can't really get into it because it's dark. I did that in several images: you're confronted but you have some way around it. In *Basement Flat* [p. 17] you're denied any exit, you don't even have a floor to stand on, to give you a sense of how far you are from the wall. In *Exit* [p. 105] you see a little bit of the gymnasium floor so you've got someplace to stand, but in *Basement Flat* you don't. You're confronted by this flat surface, so you're denied any sense of space. I talked about the pleasure of painting, the joy of putting paint on, of getting the light to look right. But I also need to be able to get a feeling of absence. The "subject" is the starting point, but after that it's a matter of line and tone, of colour and the juxtaposition of colours. It's also a matter of the manipulation of paint, and all on a two-dimensional surface. It's like a hike to a place where you've never been before – you don't know where you're going until you get there. But we were talking about space and, yes, being able to describe and get a sense of space is very important in my work.

You're known primarily for your landscape and architectural imagery, but you've also done figure works, at least earlier in your career. What role has the figure played for you?

I haven't done many paintings that have figures in them…and the figure paintings I have done have been paintings in which the figure was the principal and not just an incidental subject…When I first came to Salmonier in 1963 I was only four years downstream from an intensive introduction to and preoccupation with life drawing at the Glasgow School of Art. It was very old-fashioned, academic training. So when I set up a studio and got to work here I believed that was where I should start. I saw drawing from life as being central to what an artist should be, a responsibility, an issue of credibility. So I found models. At first they were friends from St. John's, but I soon found out that it wouldn't be as hard as I had imagined, let alone impossible, to find models in the local community. It was an opportunity I hadn't expected, and a gift, because they offered me a connection with the pulse of the place where I had chosen to live…I never lost interest in figure drawing and painting, but the few things I have done in recent years – *Blue Dianne* [p. 106] and *Girl with a Black Towel (Pink Madonna)* [p. 107] – are based on older drawings. I became more preoccupied and I suppose more comfortable with other things. But the figure work I did and the people who made it possible were very important to me. They still are.

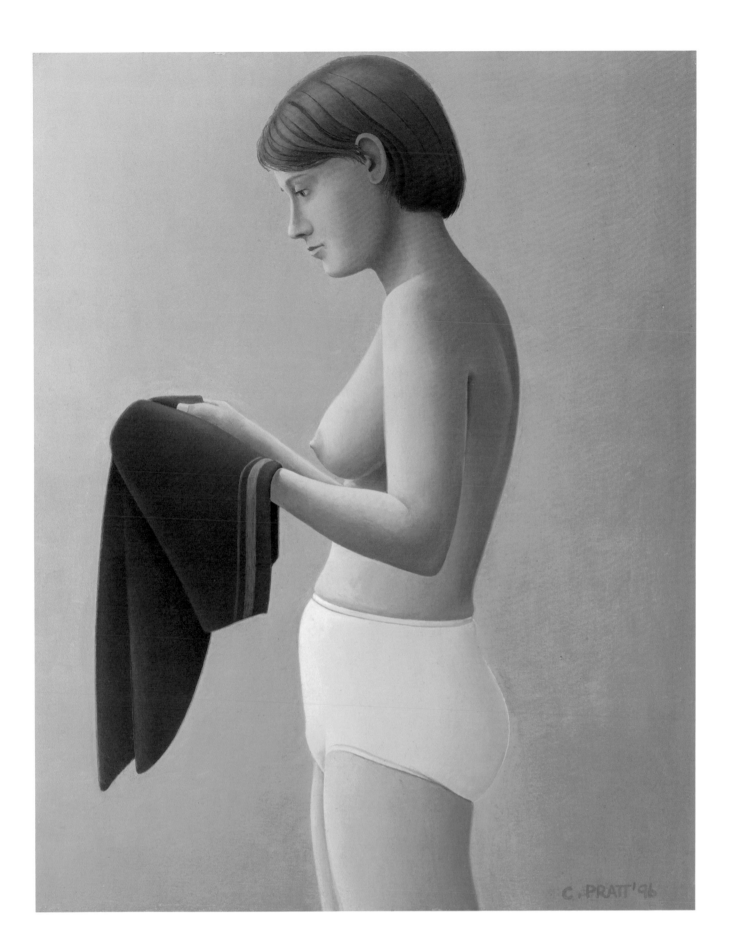

Has your recent work changed?

The work that I've done in the past fifteen years is substantially different from my earlier work. There was definitely a transitional period…There was a time around 1992 when my wife and I separated, not formally, but Mary moved into St. John's and I stayed in Salmonier by myself and had the whole studio space to myself, and that was a big change. At the same time a studio I had built in order to get out of the domicile had burned down. I had just started working there and things were going very well and suddenly it was gone. In retrospect, I think I was clinically traumatized. I got into an almost prenatal position professionally and went back to doing the kinds of things that I had done when I first started painting. I got more and more concerned with the brevity of life and passage of time, whereas for the first twenty-five years of my career I had worked up paintings by doing rough sketches on paper, developing things slowly, and thinking about and letting things grow over time. I had a whole pile of things that I wanted to do, a backlog, and normally I would take something off the bottom of the pile because it had been there gestating or maturing the longest. After the fire I decided I didn't have time for that anymore, that I should get on with things that interested me while they were fresh. One of the first paintings that came from that was *White-Out at Witless Bay Overpass* [pp. 32–33]. I had driven into St. John's in a blizzard, a big, blinding blizzard, which I love doing as long as it's (relatively) safe. It was exciting and it occurred to me that "one of these days" I must do a painting about it. I had scribbled a few slogans on my wall. One of them was, "If not now, when?" and another, "Life is not a rehearsal." So I decided I was just going to do that painting then and there. I put something else aside to do it. I did go back and forth and attend to some older ideas – I still do – but after that my work became much more immediate, and it has more to do with what I did last month or where I was last summer and the life I am living now, an experience I've had more recently, like in *Winter at Whiteway* [p. 37] or the *Driving to Venus* paintings [pp. 70–74].

What do these changes mean in terms of the actual paintings?

The work isn't less introspective, it's just more immediate and deals with a more recent period in my life. I'm more willing to accept and include the details that time and memory used to erase, to risk the edge of narrative and accept the poetry and mystery of using actual place names in the titles I invent. I always loved the names of places where we went camping, fishing, driving, or even in our imaginations. I guess it all still has to do with memory. Everything seems to have caught up to me – the past and the present become one and the same thing.

Ottawa, 17 November 2004

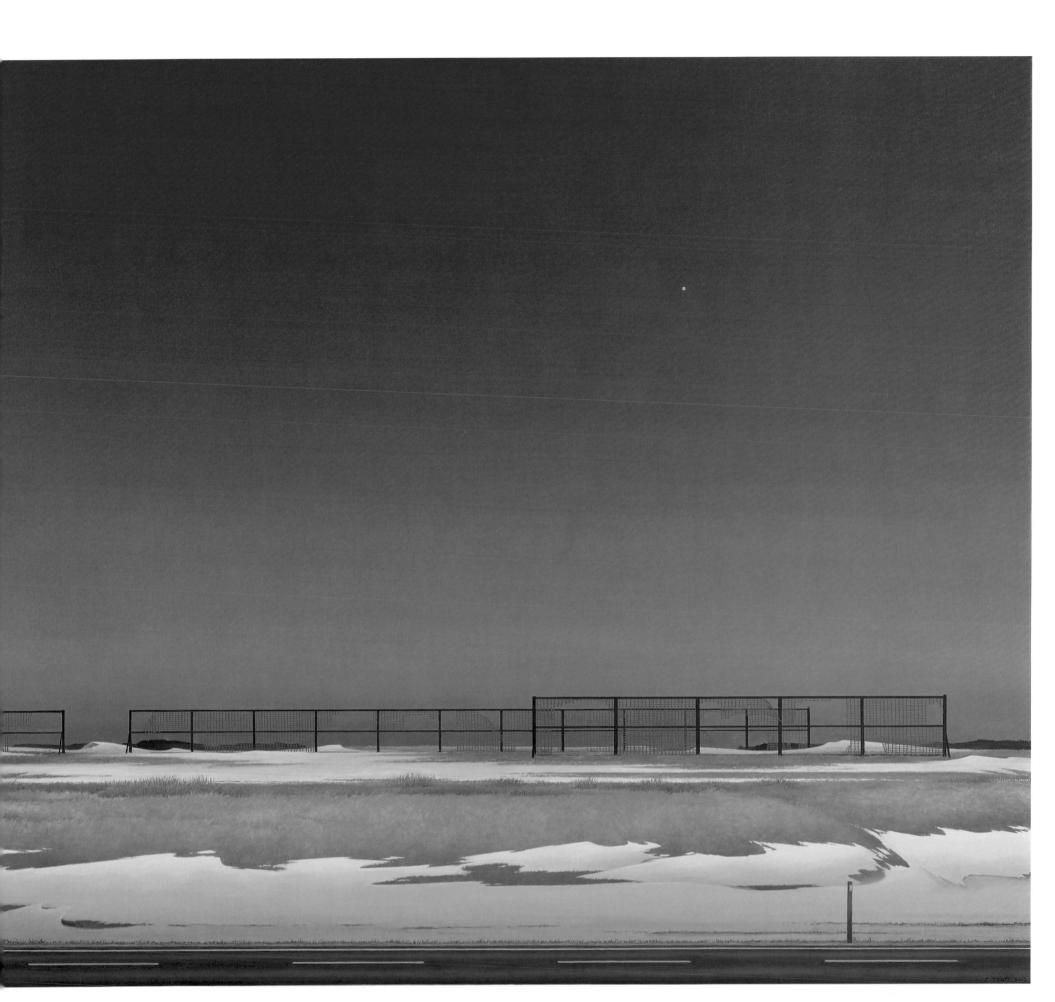

CHRONOLOGY

1935
9 December: Born John Christopher Pratt in St. John's, Nfld., to Christina Emily (Dawe) and John Kerr Pratt. Greatly influenced by grandfather James C. Pratt, businessman and musician, who began painting as a hobby in 1945, after his 65th birthday.

1939–46
Spends summers at Topsail and Bay Roberts.

1940–52
Attends Holloway School and Prince of Wales College, St. John's.

1944
Travels by train with his father to the west coast of Newfoundland for the first time.

1946
16 February: Brother Philip born.

1946–52
Spends summers at Bay Roberts, Ocean Pond, and Placentia.

1947
Visits the far corners of the Avalon Peninsula (Trepassey, Bay de Verde, the Cape Shore, and points en route) with his father, staying at local inns.

1949
Thirteen years old when Newfoundland joins Confederation.

1 Family of Rev. John Pratt with E.J. Pratt (standing left) and Jim (James C.) Pratt, the artist's grandfather (standing right), c. 1895.

2 Emily Christina Dawe, the artist's mother, as a child.

3 At the LeMarchant Road flat, 1941.

4 With Dad and Norwegian sailors, 1940.

5 In front of Dad's Studebaker, fishing, c. 1940.

6 With parents and Philip at Waterford Bridge Road, 1947.

7 With Mary West at Owens Art Gallery, Mount Allison, 1955.

8 With Len Pike (centre) and Don Hollett (right) at St. Mary's Bay, June 1952.

9 With friends at "the Barn" residence, Mount Allison, 1954.

10 Camping at a construction site, 1955.

111

1952

Graduates from high school and begins painting with watercolours while convalescing after an appendectomy. Enrols in pre-engineering at Memorial University of Newfoundland, St. John's.

1953

Wins first prize for the watercolour painting *Shed in a Storm* (1953) in Government of Newfoundland and Labrador Arts and Letters Competition.

Works in the summer for the provincial Department of Forestry, hand-colouring maps indicating forest survey areas. Enrolls in pre-medicine at Mount Allison University, Sackville, N.B. Accepted in the fall as a part-time student at the School of Fine Arts by Ted Pulford, Alex Colville, and Lawren P. Harris. Harris writes to John (Jack) Pratt that his son should pursue a career in art. Meets Mary West, a first-year fine arts student.

1954

Wins first prize for the watercolour *The Bait Rocks* (1954) and for poetry in Government of Newfoundland and Labrador Arts and Letters competition.

Works in the summer as a fisheries warden at Piper's Hole River and Southeast Placentia River; sketches at both locations. Returns to Mount Allison in the fall and enrols in the Faculty of Arts. Wins university literary competition in poetry and short story categories.

1955

Wins first prize for the watercolour *A Cove in Winter* (1955) and poetry in Government of Newfoundland and Labrador Arts and Letters competition.

Works in the summer in his father and grandfather's business, J.C. Pratt & Co. Ltd., installing, servicing, and refilling fire extinguishers. Camps and fishes for salmon with brother at Little Rapids on the Humber River.

Returns to Mount Allison in the fall. A group project creating large-scale murals and dioramas for the junior prom leads him to abandon pursuit of a BA. Quits university at Christmas and returns home to St. John's to paint full time.

1956

Sets up a studio in his bedroom, painting watercolours and experimenting with gouache and oils.

Begins construction of a cabin on land purchased on the Southeast Placentia River; sketches there and on the Cape Shore. Travels to New York, visiting the major galleries. On the way home, visits the Ontario College of Art, University of Toronto, and great uncle E.J. Pratt. Mary West moves to St. John's after completing her Diploma in Fine Arts at Mount Allison.

August: Grandfather Pratt dies.

1957

Decides to go to art school in the fall and works in the summer as a construction surveyor at the American naval station in Argentia to earn money for upcoming expenses.

12 September: Christopher and Mary wed in Fredericton, N.B., then sail to Liverpool and take the train to Glasgow. Christopher enrols in the two-year foundation program at the Glasgow School of Art, where he receives important direction from program head and teacher Jessie Alix Dick.

1958

Returns home in the summer to work at Argentia again; lives in the cabin at Southeast Placentia and sketches on the Cape Shore and Southeast River.

July: Son John born.

Returns to Glasgow in the fall and completes the general course.

1959

Again works at Argentia in the summer, living in the cabin and sketching on the Cape Shore.

Makes his first silkscreen print, *Haystacks in December*.

1959–61

Christopher and Mary return to Mount Allison School of Fine Arts.

1960

May: Daughter Anne born.

Returns to the cabin at Southeast Placentia in the summer and focuses on painting. Does studies for *Demolitions on the South Side*. Paints and sketches on the Great Northern Peninsula, north to the River of Ponds.

In the fall, returns for his final year at Mount Allison.

1961
Cabin at Southeast Placentia destroyed in February by fire.

While still at Mount Allison, on behalf of Memorial University he meets with Russell J. Harper at the National Gallery of Canada to arrange the new Memorial University Art Gallery's inaugural show; work shown is from the National Gallery collection. Christopher and Mary graduate with BFAs and return to St. John's. Christopher is appointed Specialist in Art at Memorial University, becoming the gallery curator and teaching extension classes at night.

Jury selects his second serigraph print, *Boat in Sand* (1960), for the National Gallery's *Fourth Biennial Exhibition*; print subsequently purchased by the gallery. Purchase Award for *Demolitions on the South Side* at *Atlantic Awards Exhibition*, Dalhousie University, Halifax.

Family rents a property with two cottages at Salmonier, St. Mary's Bay, for the summer. Buys a 34' trap skiff Walrus and keeps it at Kielley's wharf in Forest Field; cruises St. Mary's Bay during summers until selling Walrus in 1967.

1962
Paints *House and Barn*, his only painting while on staff at Memorial, and shows it in the National Gallery's *Fifth Biennial Exhibition*. Organizes and teaches art classes in rural communities. Over the summer, sketches in oils from nature.

1963
February: Daughter Barbara born.

Resigns from Memorial in the fall. Moves with his family to the Salmonier property, purchased in 1962, and sets up a studio in the second cottage. Paints watercolours of rooms, sheds, and stages on nearby St. Joseph's Beach.

1964
Does his first figure drawings since leaving Glasgow in 1959. Resumes silkscreen printmaking; prints *Sheds in Winter*. Paints *Woman at a Dresser* and shows it in the National Gallery's *Sixth Biennial Exhibition*. Fellow Newfoundlander Sandra Fraser Gwyn features the painting in her exhibition review for the Canadian edition of *Time Magazine*.

August: Son Edwyn born.

1965

Paints *Young Girl with Sea Shells*, featuring a boy and girl remembered from childhood; adapts the Adam and Eve theme in response to living on the southern Avalon and to the model, Bernadette, who later became the subject of other drawings and paintings.

First solo show, *Exhibition of Paintings, Drawings and Prints by Christopher Pratt*, organized by Memorial University and toured on the Atlantic Provinces Art Circuit.

Becomes Associate of the Royal Canadian Academy (ARCA) and Member of the Canadian Society of Graphic Art.

First of eight annual summer trips to coastal Labrador aboard the yacht Hemmer Jane with father, brother Philip, uncle Chester Dawe, Fred Clarke, Bob Chancey, and later, David Silcox. Teaches summer school courses at Mount Allison.

1966

Paints *Young Woman Dressing* and *Bernadette* (the latter destroyed in the 1992 studio fire).

Meets Richard Gwyn and Sandra Fraser Gwyn, who become fast friends and mentors.

1967

Paints *Young Woman with a Slip* (Bernadette) and continues figure drawing and printmaking.

Sells Walrus and takes up sailing in a C&C Paceship Blue Jacket he names Harlequin. Sails on Conception Bay and St. Mary's Bay until fall 1971.

1968

Paints *Shop on Sunday*, shown in the National Gallery's *Seventh Biennial Exhibition*, and *House in August*, beginning a series based on the look of light on outport buildings. The serigraph print *The Stamp: 2¢ Cod* begins a series based on Newfoundland stamps.

Meeting David Silcox leads to a lasting friendship.

1969

Paints *Shop on an Island* and begins a long series of drawings of Donna Meaney.

Travels across Canada with Canada Council for the Arts Visual Arts Jury, including David Silcox, Ulysse Comtois, and Dorothy Cameron. Meets many of his contemporaries for the first time: Iain Baxter, Greg Curnoe, Claude Breeze, Charles Gagnon, Yves Gaucher, Brian Fisher. Also meets his future art dealer Mira Godard, who visits his studio later that year, beginning a continuing friendship and business relationship.

14 On the Hemmer Jane, Labrador, 1969.
From left: Jack Pratt, Fred Clarke, Philip Pratt,
Bob Chancey, Christopher Pratt.

15 With Mira Godard at Salmonier, 1988.

16 In the studio, 1970.

17 Family swimming at the Tickles, c. 1970.

1969–75

Member, Mount Carmel Town Council, St. Mary's Bay.

1970

Paints his first work referring to his dislike of travelling, *Window with a Blind*, based on a remembered hotel room.

First solo show at Galerie Godard Lefort, Montreal, includes *Woman at a Dresser* (1964), *Woman and Stove* (1965), *Shop on an Island* (1969), and *House in August* (1969).

Meets photographer and friend John Reeves.

1971

Paints *Night Window* and *The Bed*. A family friend from St. John's poses for the drawing *A Woman in Black*. Prints the silkscreen *The Sheep*.

Video documentary *The Pratts of Newfoundland* (Telescope, CBC Television); features Christopher and Mary's life and work in Salmonier.

Spends three weeks touring Newfoundland, living in a Volkswagen bus and sketching. Directly involved in the provincial election campaign that ended Premier Joey Smallwood's 23 years in office.

1972

Paints *Station*, the first of several multi-panel paintings. Trips to Labrador lead to studies for the painting *Whaling Station* (1983) and the prints *Ice* and *Strait of Belle Isle*. Continued drawing of Donna Meaney leads to *French Door* (1973) and other paintings.

Hon. D.Laws, Memorial University, St. John's. Hon. D.Litt. Mount Allison University, Sackville, N.B., presented by Lawren P. Harris; addresses the convocation.

Buys a C&C 30 fibreglass sloop Walrus Too; races on Conception Bay and cruises the Newfoundland coast, which he continued to do until 1990.

1972–75

Member, Stamp Design Advisory Committee, Government of Canada, with Alan Flemming, Charles Gagnon, David Silcox, Doris Shadbolt, and others.

1973

Completes six paintings, including *Institution*, *Subdivision*, and *Cottage*, and the serigraph prints *Labrador Current* and *Good Friday*.

Appointed Officer of the Order of Canada.

Cruises north to White Bay with brother Philip and son John in Philip's C&C 35 sloop Lynx.

1974

Sailing from Niagara-on-the-Lake to Newfoundland on the C&C 39 Proud Mary leads to the prints *Cape St. Mary's* and *New Boat* (1975), and *Lake Ontario* and *Breakwater* (1976). Cruises to Conception Bay, Trinity Bay, Bonavista Bay, and St. Mary's Bay.

Meets Meriké Weiler, who later co-authors *Christopher Pratt* with David Silcox (Scarborough, Ont.: Prentice-Hall, 1982).

1975–81

Travels extensively as a Canada Council for the Arts board member.

1976

Paints *March Night* while his father's health declines rapidly and other illnesses trouble the family.

Meets artists and friends Tim Zuck and Jeffrey Spalding.

1977

Prints his first lithograph, *Nude by Night Window* (a.k.a. *Fisher's Maid*), based on earlier figure drawings. Prints *House at Path End* and paints *The Visitor*, one of several images related to travelling. Buying the C&C 43 Dry Fly and sailing from Lake Ontario to Newfoundland leads to the prints *Above Montreal* and *Light Northeast* (1979).

1978

Paints *Basement Flat*. Paints *Summer Place* based on a 1975 series of drawings of Donna Meaney. Makes preliminary *Hawke Harbour* studies that later become the painting *Whaling Station* (1983).

Cruises to Nova Scotia and races Dry Fly at Halifax and Chester Race Week.

1979

Paints *Trunk*, which he relates to his father's declining health. Paints *Exit*.

18 Ned and Barby on Dry Fly, 1977.

19 At Harricott, 1978. From left: Christopher, Anne, Mary, Barby, John.

20 With John Carter and the new flag of Newfoundland and Labrador, St. John's, 1980.

21 With Mary Pratt at Salmonier River, 1981.

22 At Salmonier, 1982. From left: Anne, Alix (holding Katherine), Mary, Barby.

117

1980

Paints *Me and Bride*, the only painting finished in a year focused on figure drawing and printmaking. Designs flag for the Province of Newfoundland and Labrador by invitation of a bipartisan legislative committee.

Publication of limited edition book *Christopher Pratt*, featuring silkscreen prints *Western Shore* (1979), *Hawke Bay* (1980), and *Labrador Sea* (1982) (Toronto: Quintus Press). Brenda (Power) Kielley assists with flag and book projects, later becoming his secretary.

Commodore, Royal Newfoundland Yacht Club.

10 November: Father dies.

1981

Paints *Dresser and Dark Window* and *Bed and Blind*.

A St. John's house/studio planned as a *pied-à-terre* become a four-storey house with two studios, leading to a decision in December to live there "full-time."

1982

January: Returns to live in Salmonier after only three weeks in St. John's.

The painting *Flashlight* becomes a companion to *Trunk*; the two become a quartet with *Dresser and Dark Window* and *Bed and Blind*.

Publication of *Christopher Pratt*, by David Silcox and Meriké Weiler.

1983

Paints *Whaling Station*. Experiments with large figure drawings on board that are cut down to become the paintings *Portrait of a Young Woman*, *Portrait of Denise*, and *Portrait of Denise 2*.

Appointed Companion of the Order of Canada.

1984

Paints *Girl in a Spare Room* based on 1982–84 drawings of one of several models. For the third time since 1963, destroys many notes, sketches, and resource materials he feels are fruitless. Jeanette Meehan becomes his studio assistant.

Luke Rombout, director of the Vancouver Art Gallery, visits the studio to discuss the possibility of mounting a retrospective exhibition; guest curator Joyce Zemans becomes a friend and mentor. Christopher and Mary are visiting artists at the Banff School of Fine Arts, at the invitation of Tim Zuck.

1985
Prints *Spring at My Place* and *August 1939*.

Christopher Pratt: A Retrospective, Vancouver Art Gallery; travels to the Art Gallery of Ontario, Toronto; Memorial University Art Gallery, St. John's; and Dalhousie Art Gallery, Halifax.

1986
Focuses on silkscreen and lithography, printing the silkscreens *Night on the Verandah* and *Stationary High*.

Travels extensively in connection with the retrospective. Seeing the show as an opportunity to review his work to date and chart a future course, he changes the studio layout and does many preliminary sketches and drawings to be developed later.

Hon. D.Laws, Dalhousie University, Halifax. Poetry readings at London Regional Art Gallery, London, Ont., and other locations.

1987
Paints *Big Boat* and *Private School*. Continues emphasis on printmaking with the silkscreens *Summer on the Southeast*, *Winter Moon*, and *Night on the River*.

Emma Butler becomes his dealer in St. John's.

Realities: Voices from Newfoundland (TV Ontario); interview by Richard Gwyn.

1988
Convinced by the retrospective that many earlier works, especially prints, would succeed as larger-scale paintings, he paints *Tower Light and Tanker*, based on the print *Light Northeast* (1979), and *Emptied Room*, based on the drawing *The Empty Room* (1964). Paints *Night Road*, the first in a series of road paintings.

1989
Paints *Woman Wearing Black*, based on the drawing *Woman in Black* (1971).

Begins construction of a new studio across the road from the family home.

1990
Moves into the new studio in June. Paints *Black Pickup* and *In the Heat of Summer*. Sets up a new print studio and prints *Lance Point Rock*.

1991
Prints *Fox Marsh Siding* and *A Boat and the Moon*. Paints *Coal Smoke*, based on the drawing *St. John's Centre* (1969), and *Pedestrian Tunnel*.

23 Racing Dry Fly with Philip (top) and John Henley (right), 1989.

24 The artist in 1991.

26 Wearing his Picasso shirt and hat from Medicine Hat, c. 1989.

25 With Jeanette Meehan and Master Printer George Maslov at Sir Wilfred Grenfell College printshop, Corner Brook, 2000.

119

The Prints of Christopher Pratt 1958–1991, Mira Godard Gallery, Toronto; catalogue raisonné with essays by Jay Scott and Christopher Pratt (St. John's: Breakwater Books / Toronto: Mira Godard Gallery); tours extensively 1992–95.

1992

8 January: New studio is destroyed by fire. Regroups in the old studio, beginning a series of small multimedia works after the loss of work in progress. Paints *A Room at St. Vincent's.*

Inducted into the Newfoundland and Labrador Arts Council Arts Hall of Honour.

Gives up sailboat racing and spends more time hiking around Newfoundland. Mary moves to live and work in the St. John's house/studios.

1993

Paints *Moose and Transports, Freight Shed,* and *Big Cigarette.* Does many small multimedia works, often reminiscent of the years at the Southeast River cabin, Argentia naval station, and Cape Shore.

1994

Continues producing small watercolour and multimedia works; many become studies for later paintings.

1995

Begins making lithograph prints at Sir Wilfred Grenfell College in Corner Brook with Jeanette Meehan and Master Printer George Maslov, and becomes reacquainted with Newfoundland's west coast. The paintings *Road Between Night and Day, Basement with Two Beds,* and *Ferry Terminal* develop from earlier multimedia studies.

Publication of *Christopher Pratt: Personal Reflections on a Life in Art,* with an introduction by David P. Silcox, and prose and journal excerpts by the artist (Toronto: Key Porter). Video profile *Originals in Art: Christopher Pratt* (Sleeping Giant Productions, Toronto).

1996

Prints the silkscreen *The Raven.* Decides to do more work based on recent ideas, events, and encounters; paints *Witless Bay Overpass* and *White-Out at Witless Bay Overpass.* In the absence of studio models, returns to figure painting by working from earlier drawings; paints *Girl with a Black Towel (Pink Madonna)* and *Blue Dianne.*

Buys a C&C 37 sloop he names Dora Maar. Mother has a stroke and is hospitalized for the rest of her life.

1997

Stops silkscreen printmaking because of the labour involved and concerns about solvent exposure. Builds a small cottage/studio on Mad Rocks Road, Bay Roberts, and continues frequent visits to Newfoundland's west coast and Corner Brook. Paints *Jack's Dream of Summer* and *Argentia Bunker, August 1989*, and prints the lithograph *Above Gander Lake*.

Video biography *The Life and Times of Christopher and Mary Pratt* (CBC Television).

1998

Makes his first collages, including *Self Portrait: Who is This Sir Munnings?* Paints *Ferolle Point Light* and *Benoit's Cove: Sheds in Winter*. Titles referring to actual places become more important and are often independent of any literal depiction of the place itself.

Gives Pratt Lecture (named for great uncle E.J. Pratt) at Memorial University.

1999

Paints *Deer Lake: Junction Brook Memorial* and the *Trout River Hills* paintings. *Military Presence* and *The Americans: Off Base Housing* develop from multimedia works dealing with the Argentia years and recent visits to Stephenville, Nfld.

Christopher Pratt at the Mira Godard Gallery – A 30th Anniversary Exhibition, Toronto; catalogue features the artist's writing.

The Bay Roberts Heritage Society names its new art gallery in Bay Roberts after him and features his work in the inaugural exhibition.

Honorary Chairman, Bay Roberts Heritage Society.

2000

Visits to Newfoundland's west coast result in the *Driving to Venus* paintings (2000–01) and several small, informal lithographs. Tears down the old studio and rebuilds it as a large, open working space.

2001

Paints *Half Moon and Bright Stars: My Bedroom in September* and continues with west coast images: *A Blizzard at Boswarlos* and *Railcar Camper: Twilight at Peter Stride's Lake*.

Donates 26 prints that were exhibited at Rideau Hall, Ottawa, to the Canadiana Fund State Art Collection. Launches Web site, *Drawing From Memory: The Art and Life of Christopher Pratt*, a partnership project between Industry Canada and the Art Gallery of Newfoundland and Labrador (formerly Memorial University Art Gallery): <http://collections.ic.gc.ca/pratt>

16 September: Mother dies.

27 Working on *Deer Lake: Junction Brook*
 Memorial, 1999.

28 At Eddies Cove East, 2000.

29 At Greenland, Conception Bay, August 2001.

30 With Jeanette Meehan in the studio, May 2005.

31 In the studio, May 2005.

121

2002

The new studio space leads to a very productive year, with paintings developed from increasingly larger watercolour and multimedia studies: *Love in Late Summer*, *A Storm on My Porch*, *Snow Fence and Mars*, *Suburbs Standing West*, *Flower's Island Light*, *Crab Plant with Cat Tracks*.

Video profile *Mon Palmarès, Christopher Pratt*, ARTV, Ontario. (French with English subtitles.)

2003

Visits to west and northeast coasts of Newfoundland lead to the paintings *East Bay, Port au Port Bay* and *Bear Cove, on the Strait of Belle Isle*. Growing emphasis on larger watercolour and multimedia works, including *Red Indian Lake* and *ASARCO (On the Buchan's Plateau)*.

At Memorial University Landscapes of Memory performance, reads his poetry in conjunction with soprano Jane Leibel, flutist Michelle Cheramy, and composer Jack Behrens.

2004

Paints *Winter at Whiteway* and *A Blizzard on Branch Country: Snow Fence and Ptarmigan*. Completes several small minimalist paintings based on the Strait of Belle Isle. Summarizes the experience of wandering the island with his longtime assistant Jeanette Meehan in the painting *Sunset at Squid Cove*.

Poetry reading at the March Hare, St. John's.

Christopher and Mary divorce after a 12-year separation.

2005

Paints *Barn and Cellar: August 1939* and *Long Shed*. Continues with watercolour and multimedia works.

Exhibits in inaugural show at The Rooms, Provincial Art Gallery Division, St. John's (formerly the Art Gallery of Newfoundland and Labrador).

Publication of *A Painter's Poems*, a collection of the artist's poetry (St. John's: Breakwater Books. The Newfoundland Poetry Series); reading at the Writers at Woody Point Festival.

SELECTED EXHIBITIONS

SOLO EXHIBITIONS

1965
Memorial University Art Gallery, St. John's; toured the Atlantic Provinces Art Circuit

1966
Exhibition of Paintings, Drawings and Prints by Christopher Pratt, Atlantic Provinces Art Circuit

1970
Memorial University Art Gallery, St. John's, in collaboration with Galerie Godard Lefort, Montreal; Agnes Etherington Art Centre, Kingston, Ont.; Edmonton Art Gallery; Mendel Art Gallery, Saskatoon, Sask.; Vancouver Art Gallery; Galerie Godard Lefort, Montreal (catalogue)

1972
Memorial University Art Gallery, St. John's

1972–73
Atlantic Provinces Art Circuit

1973
Christopher Pratt Serigraphs, Beaverbrook Art Gallery, Fredericton, N.B.

1974
Marlborough Godard Gallery, Toronto

1976
Marlborough Godard Gallery, Montreal, Toronto, and New York (catalogue)

1978
March Crossing and Proofs, Mira Godard Gallery, Toronto and Montreal (catalogue)

1980
Christopher Pratt: Prints, Related Studies, Collages, Stencil Proofs 1975–1980, Memorial University Art Gallery, St. John's

1982
21 Figure Drawings, Mira Godard Gallery, Toronto

1982–85
Christopher Pratt Paintings, Prints and Drawings, Canada House Gallery, London, England; travelled to Paris, Brussels, and Dublin

Christopher Pratt: Silkscreen Prints 1960–1982, Canada House Gallery, London, England; travelled to Rome; Glasgow; Billingham and Berkshire, England; Dublin; Vienna

1983
Mira Godard Gallery, Calgary

Centro di Cultura di Palazzo Grassi, Venice

1984
Christopher Pratt: Interiors, Mira Godard Gallery, Toronto (catalogue)

1985–86
Christopher Pratt: A Retrospective, Vancouver Art Gallery; Art Gallery of Ontario, Toronto; Memorial University Art Gallery, St. John's; Dalhousie Art Gallery, Halifax (catalogue)

Christopher Pratt Prints, American Associated Artists Gallery, New York

1988
Christopher Pratt: Recent Paintings, Mira Godard Gallery, Toronto; 49th Parallel Gallery, New York (catalogue)

1992–95
Christopher Pratt Prints: 1958–1991, Mira Godard Gallery, Toronto; Memorial University Art Gallery, St. John's; Canadian Embassy Gallery, Washington, D.C.; Nickel Art Gallery, Calgary; Edmonton Art Gallery; University of Waterloo Art Gallery; Art Gallery of Nova Scotia, Halifax; Whitehorse, Y.T.; Burnaby, B.C.; Kamloops, B.C.; Sir Wilfred Grenfell College, Corner Brook, Nfld.; Beaverbrook Art Gallery, Fredericton, N.B. (catalogue)

1993
Christopher Pratt: New Work, Douglas Udell Gallery, Edmonton

Christopher Pratt: New Paintings, Mira Godard Gallery, Toronto

Christopher Pratt: Recent Prints – 10th Anniversary Show, Paul Kuhn Gallery, Calgary

1994
Dominion Gallery, Montreal

Christopher Pratt: Images of Memory – New Multi-media Works, Emma Butler Gallery, St. John's

Inaugural exhibition, Redpath Gallery, Vancouver

1995
Christopher Pratt: New Paintings, Mira Godard Gallery, Toronto

1997

Christopher Pratt: The Witless Bay Paintings, Mira Godard Gallery, Toronto

Dominion Gallery, Montreal

1997–98

Christopher Pratt: The Boat, Selected Images 1957–1997, Art Gallery of Newfoundland and Labrador, St. John's; Barbour Premises, Newtown, Nfld.

1999

Christopher Pratt at Mira Godard Gallery: A 30th Anniversary Exhibition, Mira Godard Gallery, Toronto (catalogue with text by the artist)

2002

Christopher Pratt: New Paintings, Mira Godard Gallery, Toronto

2003–05

Christopher Pratt: Places I Have Been, National Gallery of Canada, Ottawa; Thunder Bay Art Gallery; Centre d'exposition de Jonquière (catalogue)

2004

Christopher Pratt: Fall at My Place, Mira Godard Gallery, Toronto

2005–07

Christopher Pratt, National Gallery of Canada, Ottawa; Art Gallery of Nova Scotia, Halifax; The Rooms, Provincial Art Gallery Division, St. John's; Winnipeg Art Gallery (catalogue)

GROUP EXHIBITIONS

1961

Atlantic Awards Exhibition, Dalhousie Art Gallery, Halifax

Eighth Annual Young Contemporary Painters, London Public Library and Art Museum

1961–68

Consecutive Biennial exhibitions, National Gallery of Canada, Ottawa

1962

First Biennial Winnipeg Show, Winnipeg Art Gallery

1965

32nd Annual Exhibition, Sarnia Library and Art Gallery

Fifth Annual Calgary Graphics Exhibition, Nickel Art Gallery, Calgary

8th Annual Exhibition and Sale of Canadian Art, Montreal Museum of Fine Arts

Canadian Society of Graphic Art, Sarnia Library and Art Gallery

1966

Magic Realism in Canadian Painting, London Public Library and Art Museum

Tenth Winnipeg Show, Winnipeg Art Gallery

Artists of Atlantic Canada, National Gallery of Canada, Ottawa; Atlantic Provinces Art Circuit

1967

Second Atlantic Awards Exhibition, Dalhousie Art Gallery, Halifax

Twenty Canadians, Douglas Gallery, Vancouver

Atlantic Provinces Pavilion, Expo '67, Montreal

Calgary Graphics Exhibition, Alberta College of Art, Calgary

1968

Canadian Society of Graphic Art, 35th Annual Exhibit 1968, London Public Library and Art Museum

Kingston Spring Exhibition of Art, Agnes Etherington Art Centre, Kingston, Ont.

1969

36th Annual Exhibition, Robert McLaughlin Gallery, Oshawa, Ont.

1971

Canadian Society of Graphic Art, Oshawa, Ont.; Washington, D.C.

Painters in Newfoundland, Memorial University Art Gallery, St. John's

1972

Yves Gaucher and Christopher Pratt, Vancouver Art Gallery; touring exhibition

1973

Canada Trajectoire, Musee d'art Moderne, Paris

A Personal View of James Pratt, Mary Pratt, Christopher Pratt, Memorial University Art Gallery, St. John's

10 Newfoundland Artists, New Brunswick Museum, St. John

1974

Colville, Pratt, and Forestall, Beaverbrook Art Gallery, Fredericton, N.B.

Artist's Stamps and Stamp Images, International Invitational Exhibition, Simon Fraser University Gallery, Vancouver

The Acute Image in Canadian Art, Owens Art Gallery, Sackville, N.B.

D.P. Brown, Ken Danby, Tom Forrestall, Christopher Pratt, Centre culturel canadien, Paris; Centre culturel et d'information, Canadian Embassy, Brussels; Canada House Gallery, London, England

Thirteen Artists from Marlborough Godard, Marlborough Godard Gallery, Montreal and New York

1975

The Canadian Canvas, travelling exhibition organized by Time Canada

Marlborough Godard Multiples, Marlborough Godard Gallery, Toronto and Montreal

1975–76

Images of Women, Winnipeg Art Gallery

Wallace S. Bird Memorial Collection, Beaverbrook Art Gallery, Fredericton, N.B.; Art Gallery of Nova Scotia, Halifax; Memorial University Art Gallery, St. John's; Mendel Art Gallery, Saskatoon; New Brunswick Museum, Saint John; Galerie Restigouche, Campbellton, N.B.

1976

Twenty Canadians, Douglas Gallery, Vancouver

Atlantic Graphics, Beaverbrook Art Gallery, Fredericton, N.B.

Changing Visions: The Canadian Landscape, Edmonton Art Gallery; Art Gallery of Ontario, Toronto

1976–78

Aspects of Realism, travelling exhibition organized by Rothman's of Pall Mall Canada Ltd.

1977

Equinox Gallery, Vancouver, B.C.

Canadian Tapestries 1977, Art Gallery of Ontario, Toronto

1977–78

Yves Gaucher and Christopher Pratt, Vancouver Art Gallery and Mira Godard Gallery, Toronto; Vancouver Art Gallery; Southern Alberta Art Gallery, Lethbridge; Art Gallery of Nova Scotia, Halifax; Winnipeg Art Gallery; Art Gallery of Hamilton

1978

Coast, Sea and Canadian Art, Stratford Art Gallery

Modern Painting in Canada: A Survey of the Major Movements in 20th-Century Art, Edmonton Art Gallery

1979

Twentieth-Century Canadian Drawings, Stratford Art Gallery

1979–80

Aspects of Canadian Printmaking, travelling exhibition organized by Mira Godard Gallery, Toronto

1980

Aspects of Canadian Painting in the Seventies, Glenbow Museum, Calgary

The Bank of Nova Scotia Fine Art Collection, Mendel Art Gallery, Saskatoon

Art in the Marketplace: Selections from the Corporate Art Collectors Group, Toronto

1981

Correspondence, travelling exhibition organized by the Walter Phillips Gallery, Banff, Alta.

Realism and Expressionism in Canadian Art, Pagurian Gallery, Toronto

1982–83

Newfoundland and Labrador Editions II, Memorial University Art Gallery, St. John's; toured nationally

1983
The Nude in Canadian Art, Pagurian Gallery, Toronto

Atlantic Print Exhibition, Art Gallery of Nova Scotia, Halifax

1984
Alex Colville / Christopher Pratt / Jeremy Smith, Galerie Mihalis, Montreal

1987
Gallery Artists, Mira Godard Gallery, Toronto

1988
Artists of Newfoundland, Gallery 78, Fredericton, N.B.

1992
People's Art: XXX Anniversary, Mira Godard Gallery, Toronto

1993
10th Anniversary Show, Paul Kuhn Gallery, Calgary

Reflecting Paradise, Canadian Participation, Expo '93, Taejon, Korea

1994
Inaugural Exhibition, Redpath Gallery, Vancouver

1995–96
Land and Sea: Eight Artists from Newfoundland, Art Gallery of Newfoundland and Labrador, St. John's; toured Ireland

1996
The Boat Show: Canadian Artists – A Nautical Look, Art Gallery of North York

1998
Prints by Painters, Paul Kuhn Gallery, Calgary

1998
The Figure Show, Mira Godard Gallery, Toronto

1999
Merchants, Mariners and the Northern Seas, Sir Wilfred Grenfell College Art Gallery, Corner Brook, Nfld.; Art Gallery of Newfoundland and Labrador, St. John's

First Look, Christopher Pratt Gallery, Bay Roberts, Nfld.

2000
Landscape and Memory: Twelve Painters, Mira Godard Gallery, Toronto

Toronto International Art Fair

2001
Toronto International Art Fair

2002
Toronto International Art Fair

New York International Art Fair

2003
Certain Realities, Mira Godard Gallery, Toronto

Visual Artists of Newfoundland and Labrador: A Celebration, Sir Wilfred Grenfell College, Corner Brook, Nfld.

Toronto International Art Fair

2004
The Prints of Alex Colville, Lucian Freud, Christopher Pratt, Mira Godard Gallery, Toronto

SELECTED BIBLIOGRAPHY

CATALOGUES AND BOOKS

The Acute Image in Canadian Art. Exhibition catalogue. Sackville, N.B.: Owens Art Gallery, 1974.

Andrus, Donald F.P. *Artists of Atlantic Canada / Artistes de la côte atlantique du Canada.* Exhibition catalogue. Ottawa: Queen's Printer, 1966.

Artists' Stamps and Stamp Images. Exhibition catalogue. Burnaby, B.C.: Simon Fraser Gallery, 1974.

Aspects of Canadian Painting in the Seventies. Exhibition catalogue. Calgary: The Museum, 1980.

Aspects of Realism / Aspects du réalisme. Exhibition catalogue. Toronto: Rothmans of Pall Mall Canada, 1976.

Atlantic Awards Exhibition. Exhibition catalogue. Halifax: Dalhousie Art Gallery, 1961.

Bringhurst, Robert, Geoffrey James, Russell Keziere, and Doris Shadbolt, eds. *Visions: Contemporary Art in Canada.* Vancouver: Douglas & McIntyre, 1983.

Buchheit, Manfred et al. *Rethinking the Rural in Contemporary Newfoundland Art.* Exhibition catalogue. St. John's, Nfld.: Art Gallery of Newfoundland and Labrador, 1997.

Burnett, David and Marilyn Schiff. *Contemporary Canadian Art.* Edmonton: Hurtig, in cooperation with the Art Gallery of Ontario, 1983.

Campbell, Harry, ed. *Canadian Art Auctions: Sales and Prices 1976–1978.* Don Mills, Ont.: General Publishing, 1980.

The Canadian Canvas / Peintres canadiens actuels. Exhibition catalogue. Montreal: Time Canada, 1974.

Changing Visions: The Canadian Landscape / Aperçus divers : le paysage canadien. Exhibition catalogue. Edmonton: Edmonton Art Gallery/ Toronto: Art Gallery of Ontario, 1976.

Christopher Pratt. Exhibition catalogue. Montreal: Marlborough Godard, 1976.

Christopher Pratt. Toronto: Quintus Press, 1981.

Christopher Pratt at Mira Godard Gallery: A 30th Anniversary Exhibition. Exhibition catalogue. Toronto: Mira Godard Gallery, 1999.

Christopher Pratt Interiors. Exhibition catalogue. Toronto: Mira Godard Gallery, 1984.

Christopher Pratt: March Crossing and Proofs. Exhibition catalogue. Toronto: Mira Godard Gallery, 1978.

Christopher Pratt: Paintings, Prints, Drawings / Christopher Pratt : Tableaux, sérigraphies, dessins. London: Canadian High Commission, 1982.

Christopher Pratt: Recent Paintings. Exhibition catalogue. Toronto: Mira Godard Gallery, 1988.

Colville, Pratt, Forrestall. Exhibition catalogue. Fredericton, N.B.: Beaverbrook Art Gallery, 1974.

Correspondences: Tony Brown, George Legrady, John McEwen, Christopher Pratt, Tim Zuck. Banff, Alta.: Walter Phillips Gallery, 1981.

Creative Canada: A Biographical Dictionary of Twentieth-Century Creative and Performing Artists. Toronto: University of Toronto Press, in association with McPherson Library, University of Victoria, 1971.

Duval, Paul. *D.P. Brown, Ken Danby, Tom Forrestall, Christopher Pratt.* Exhibition catalogue. Paris: Centre culturel canadien, 1974.

———. *Four Decades: The Canadian Group of Painters and their Contemporaries 1930–1970.* Toronto: Clark, Irwin, 1972.

———. *High Realism in Canada.* Toronto: Clarke, Irwin, 1974.

Fenton, Terry and Karen Wilkin. *Modern Painting in Canada: Major Movements in Twentieth-Century Canadian Art.* Edmonton: Hurtig, in cooperation with the Edmonton Art Gallery, 1978.

Fifth Biennial Exhibition of Canadian Painting, 1963 / 5ᵉ Exposition biennale de la peinture Canadienne. Ottawa: National Gallery of Canada, 1963.

First Look: Inaugural Exhibition for the Christopher Pratt Gallery. St. John's: Art Gallery of Newfoundland and Labrador, 1999.

The Fourth Biennial Exhibition of Canadian Art, 1961 / Quatrième exposition biennale d'art canadien, 1961. Ottawa: National Gallery of Canada, 1961.

Godsell, Patricia. *Enjoying Canadian Painting.* Don Mills, Ont.: General Publishing, 1976.

Grattan, Patricia and Caroline Stone. *Twenty-Five Years of Art in Newfoundland: Some Significant Artists.* Exhibition catalogue. St. John's, Nfld.: Art Gallery, Memorial University of Newfoundland, 1987.

Lalonde, Christine. *Christopher Pratt: Places I Have Been.* Exhibition catalogue. Ottawa: National Gallery of Canada, 2003.

Lind, Jane. *Mary and Christopher Pratt.* Vancouver: Douglas & McIntyre, 1989.

Magic Realism in Canadian Painting. Exhibition catalogue. London, Ont.: London Public Library and Art Museum, 1966.

McDermott, Barb and Gail McKeown. *All About Famous Canadians from Newfoundland.* All About Series. Edmonton: Reidmore, 1999.

Merchants, Mariners and the Northern Seas. Exhibition catalogue. St. John's, Nfld.: Division of University Relations for Sir Wilfred Grenfell College Art Gallery, Memorial University of Newfoundland. 1999.

Morris, Jerrold A. *100 Years of Canadian Drawings.* Toronto: Methuen, 1980.

———. *The Nude in Canadian Painting.* Toronto: New Press, 1972.

A Personal View of James Pratt, Mary Pratt, Christopher Pratt from the Private Collection of Mr. & Mrs. J.K. Pratt. Exhibition catalogue. St. John's, Nfld.: Memorial University Art Gallery, 1975.

Pratt, Christopher. *Christopher Pratt: Personal Reflections on a Life in Art.* Intro. by David Silcox. Toronto: Key Porter, 1995.

Pratt, Christopher. *Print Catalogue Raisonné Addendum / Christopher Pratt.* St. Mary's Bay, Nfld.: C. Pratt, 2003.

Pratt, Christopher and Jay Scott. *The Prints of Christopher Pratt 1958–1991: Catalogue Raisonné.* St. John's, Nfld.: Breakwater/Toronto: Mira Godard Gallery, 1991.

Recent Paintings: Ivan Eyre, Katja Jacobs, Medrie MacPhee, Christopher Pratt. Exhibition catalogue. New York: 49th Parallel, 1988.

Reid, Dennis. *A Concise History of Canadian Painting.* Toronto: Oxford University Press, 1973; 2nd ed. 1988.

Seventh Biennial of Canadian Painting, 1968 / Septième biennale de la peinture canadienne, 1968. Ottawa: National Gallery of Canada, 1968.

Shadbolt, Doris, ed. *Christopher Pratt.* Exhibition catalogue. St. John's, Nfld.: Memorial University of Newfoundland/ Montreal: Galerie Godard Lefort, 1970.

Silcox, David P. *Christopher Pratt: Prints, Related Studies, Collages, Stencil Proofs 1975–1980.* St. John's, Nfld.: Memorial University Art Gallery, 1980.

Silcox, David P. and Meriké Weiler. *Christopher Pratt.* Scarborough, Ont.: Prentice-Hall, 1982.

Sixth Biennial Exhibition of Canadian Painting, 1965 / Sixième Exposition biennale de la peinture canadienne, 1965. Ottawa: National Gallery of Canada, 1965.

Spalding, Jeffrey. *Reflecting Paradise / Reflets du paradis.* Expo '93 Taejon, Korea. Pusan, Korea, 1993.

Thirteen Artists from Marlborough-Godard, Toronto, Montreal. Exhibition catalogue. New York: Marlborough Gallery, 1974.

Townsend, William, ed. *Canadian Art Today.* London; New York: Studio International, 1970.

Yves Gaucher and Christopher Pratt. Exhibition catalogue. Vancouver: Vancouver Art Gallery, 1977.

Zemans, Joyce. *Christopher Pratt: A Retrospective.* Exhibition catalogue. Vancouver: Vancouver Art Gallery, 1985.

ARTICLES AND REVIEWS

"Artists' Stamps and Stamp Images." *Artmagazine* 29, October/November 1976: 47–49.

"The Arts: Life Without Evasion." *Time* 88, no. 6 (5 August 1966).

"The Arts: Prairie Outburst." *Time*, 18 June 1965.

Baele, Nancy. "His Own Material World: The Christopher Pratt Retrospective." *Canadian Forum* 66, no. 763 (November 1986): 37–38.

Bruce, Harry. "Christopher Pratt: Magic as Reality." *Maclean's* 86, no. 12 (December 1973): 36–37, 42+.

———. "A Rarer Reality: Christopher Pratt Invests Everyday Objects with Mystery." *The Canadian Magazine*, 26 November 1977: 18–21.

"Business and the Arts." *Bravo*, January/February 1986: 70–74.

Carroll, Nancy. "Painting, Seeing and Christopher Pratt." *Vanguard* 11, no. 1 (February 1982): 17–19.

"Christopher Pratt." (book review) *The Art Post*, May 1983: 6.

"Christopher Pratt." *Books In Canada* 10, no. 12 (May 1981): 12.

"Christopher Pratt: Interiors." *Arts Atlantic* 6, no. 2 (spring 1985): 6–7.

"Christopher Pratt: New Paintings." *Arts Atlantic* 14, no. 2 (spring/summer 1996): 12–13.

"Christopher Pratt Prints 1958–1991." *Journal, Art Gallery of Nova Scotia* 10, September 1993–February 1994: 20.

"Christopher Pratt Prints 1958–1991." *Sir Wilfred Grenfell College Art Gallery News*, 1994.

Cook, Michael. "Christopher Pratt, tel qu'en lui-même." *Vie des Arts* 22, no. 87 (summer 1977): 42–44; English 89–90.

Dault, Gary Michael. "Christopher Pratt." *Canadian Art* 2, no. 4 (December 1985): 50–57.

———. "Heavyweight titles". *Books in Canada*, November 1982.

De Billy, Helene. "Vue de l'autre solitude : à Terre-Neuve, entre Dieu et la Grande-Bretagne, entre la vie et la mort, Christopher Pratt évoque dans ses toiles un Canada nostalgique et inquiet." *Actualité* 13, no. 9 (September 1987): 137–38.

Downton, Dawn Rae. "The Art of the Deal." *Arts Atlantic* 13, no. 3 (winter 1995): 22

Duff, Donald. "Investing Wisely in Canadian Art." *enRoute*, March 1980: 70–79.

Enright, Laurel. "Correspondences: The Conceptual Image." *Arts West* 6, no. 8 (September 1981): 39.

Kramer, Miriam. "Exhibition at Canada House." *Canadian Collector* 17, no. 6 (November/December 1982): 62.

Fetherling, Douglas. "Christopher Pratt: Mira Godard Gallery." *Canadian Art* 10, no. 4 (winter 1993): 64.

"Fine Art's Finest: The Powers Behind Canadian Art." *Canadian Magazine*, 29 March 1975.

Fleming, Marie. "Canadian Tapestries '77." *Vanguard* 6, no. 5 (June/July 1977): 17.

Fulford, Robert. "People's Art." *Canadian Art* 9, no. 2 (summer 1992): 58–59.

Greenwood, Michael. "Christopher Pratt." *Arts Canada* 33, no. 4 (December 1976/January 1977): 30–33.

———. "Review: The Canadian Canvas." *Arts Canada* 32, no. 196/197 (March 1975): 1–16.

Hammock, Virgil C. "Pratt et Pratt." *Vie des Arts* 26, no.103 (summer 1981): 45–48, 78–79.

Hanna, Deidre. "Christopher Pratt Returns With Renewed Artistic Energy." *Now Magazine*, 14–20 October 1993: 87.

Heviz, Judy. "Montreal: The Canadian Canvas." *Artmagazine* 6, no. 21 (spring 1975): 46.

Johnston, Ann. "A Brooding Vision." *Maclean's* 94, no. 38 (21 September 1981): 36–40.

Jones, Charlotte. "Christopher Pratt: New Paintings." *Arts Atlantic* 14, no. 3 (spring/summer 1996): 12–13.

Jordan, Betty Ann. "A Joy of Surfaces." *Saturday Night*, September 1978: 8.

Kimber, Stephen. "Mary Pratt Artist." *Atlantic Insight*, September 1979: 24–26.

Kritzwiser, Kay. "The Biennial: The Fruit of a Search." *Canadian Works*, 1968.

———. "Book Review: Christopher Pratt by D.P. Silcox." *Artmagazine* 14, no. 61 (December 1982/February 1983): 58–59.

Laurence, Robin. "Prattfalls: The Bride Strips Bare Her Bachelor." *Border Crossings* 15, no. 2 (May 1996): 12–17.

Livingstone, David. "The Wrought Irony of the Real World." *Maclean's* 94, 6 July 1981: 54–55.

Macfarlane, David. "The Art of Mira Godard." *Saturday Night* 96, July 1981: 19–28.

Mackay, Gillian. "Explorer in a Barren Universe." *Maclean's* 98, 9 December 1985: 62–64.

———. "Review: *Deer Lake: Junction Brook Memorial* 1999." *Canadian Art* 17, no.1 (spring 2000): 112.

"Magic Realists: Canada House Gallery: London Exhibit." *Art and Artists* 9, August 1974: 9.

"Mary and Christopher Pratt." (book review) *Quill & Quire* 56, no. 6 (June 1990): 17.

Molloy, Patricia. "Christopher Pratt: New Paintings, Mira Godard Gallery." *Arts Atlantic* 9, no. 2 (spring/summer 1989): 12.

Murphy, Tara. "Print Retrospective 1958-1991 Christopher Pratt: An Illustrated Man." *The Muse*, Memorial University of Newfoundland, St. John's, 21 February 1992: 9.

Nakoneshny, Shane. "Christopher Pratt." *Arts Atlantic* 13, no. 1 (1994): 49.

———. "The Prints of Christopher Pratt 1958-1991." (book review) *Arts Atlantic* 11, no. 3 (spring/summer 1992): 2.

Gwyn, Sandra Fraser. "The Newfoundland Renaissance." *Saturday Night* 91, April 1976: 38–45.

O'Donal, Rory. "The Subliminal Art of Christopher Pratt." *The Art Post*, May 1983: 6.

"Pages of Beauty and Fascination." (book review) *Maclean's*, 18 December 1995.

"Peintres Canadiens Actuels." *Vie des Arts* 20, spring 1975: 55.

"Portrait Christopher Pratt." *Maclean's* 93, no. 28 (12 May 1980): 28.

Pratt, Anne. "Down by the River." *East Coast Living*, summer 2001: 6, 42–43.

Braide, Janet. "Pratt Retrospective." *Canadian Collector* 20, no. 6 (November/December 1985): 89.

"The Prints of Christopher Pratt 1958–1991." (book review) *The Muse*, Memorial University of Newfoundland, St. John's, 27, March 1991: 17.

"The Prints of Christopher Pratt 1958–1991." (book review) *Quill & Quire* 58, no. 1 (January 1992): 24.

Reeves, John. "Christopher Pratt – Photographic Essay and Words." *Arts Canada* 27, nos. 148/149 (October/November 1970): 63–67.

———. "Christopher Pratt's Fine Art of Sailing." *enRoute*, May 1985: 40–49.

———. "Sea, the Wind, the Summer Sun." *Saturday Night* 92, no. 3 (April 1977): 28–33.

"Review: The Canadian Canvas." *Time*, 27 January 1975.

"Review: The Canadian Canvas." *Vanguard* 4, no. 5 (June/July 1975): 3–5.

Saari, Ruth. "Frozen Visions." *Skyword*, 1986.

Shadbolt, Doris. "Super-realist, magic realist or surrealist." *Atlantic Reporter*, 1 May 1970.

Skoggard, Ross. "Review: Marlborough Gallery." *Art Forum* 15, no. 6 (February 1977): 64–65.

Thurston, Harry. "Pratt and Pratt, Christopher and Mary: The First Couple of Contemporary Canadian Art." *Equinox* 1, March/April 1982: 72–83.

Tindal, Doug. "Art: Psst! Want a hot art book? It'll cost you only $2,100." *Atlantic Insight* 2, no. 3 (April 1980): 78–79.

"Update: Memorial University Art Gallery." *Arts Atlantic* 2, no. 1 (spring 1979): 9.

"A Visit to Newfoundland." *Arts Canada* 32, no. 4 (winter 1975/76): 41–47.

"The Visual Arts in Newfoundland." *Arts Atlantic* 1, no. 1 (fall 1977): 10–13.

Webb, M. "Christopher Pratt at Mira Godard." *Artmagazine* 12, nos. 53/54 (May/June 1981): 56–57.

Weiler, Meriké. "Christopher Pratt, à mi-carrière." *Vie des Arts* 31, no. 123 (June 1986): 69, 92.

———. "Christopher Pratt: Some Newfoundland Memories." *Artmagazine* 7, no. 25 (March/April 1976): 14–16.

Woods, Kay. "Toronto: Showcase of East and West." *Arts West* 7, no. 4 (April 1982): 22–24.

Yacowar, Maurice. "The Paintings of Mary (vs. Christopher) Pratt." *Dalhousie Review* 68, no. 4 (winter 1988/89): 385–99.

Yates, Sarah. "The Canadian Influence in Paris." *Artmagazine* 9, no. 35 (October/November 1977): 22–26.

Zemans, Joyce. "Christopher Pratt: A Retrospective." (book review) *Canadian Literature*, no. 113–14 (summer/fall 1987): 219–25.

———. "The Visual Poetry of Christopher Pratt." *AGO News* 8, no. 2 (February 1986): 1.

WORKS IN THE EXHIBITION

Woman at a Dresser
1964
oil on hardboard
67.2 × 77.5 cm
McMichael Canadian Art Collection,
Kleinburg, Ont. Gift of ICI Canada Inc.
Illustrated: p. 44

Woman and Stove
1965
oil on hardboard
76.2 × 61 cm
The Rooms Corporation, Provincial Art
Gallery Division, St. John's, Memorial
University of Newfoundland Collection
Illustrated: p. 44

Shop on an Island
1969
oil on hardboard
81.3 × 91.4 cm
Museum London. Gift of Mr. and Mrs.
John H. Moore, London, Ont., through
the Ontario Heritage Foundation, 1979
Illustrated: p. 51

Graffiti at Hawke Harbour
1972
graphite on paper
12.6 × 5.4 cm
Vancouver Art Gallery. Gift of the artist
Illustrated: p. 53

Station
1972
oil on hardboard
85.1 × 138.1 cm diptych
Confederation Centre Art Gallery,
Charlottetown. Purchased with funds
donated by Dr. Eric L. Harvie, Calgary,
1972
Illustrated: p. 13

Study No. 1: Hawke Harbour
1972
graphite and coloured pencil on paper
12.7 × 28.4 cm
Vancouver Art Gallery. Gift of the artist
Illustrated: p. 53

Woman Wearing Black
1972/1989
oil on canvas
54 cm (diameter)
Collection of David Marshall
Illustrated: p. 45

Cottage
1973
oil on hardboard
66 × 121.9 cm
Collection of K.A. Lund
Illustrated: pp. 10–11

Institution
1973
oil on hardboard
76.2 × 76.2 cm
National Gallery of Canada, Ottawa
Illustrated: p. 95

Subdivision
1973
oil on hardboard
65.1 × 90.2 cm
Musée d'art contemporain de Montréal,
Lavalin Collection
Illustrated: p. 57

*Girl with a Black Towel (Pink
Madonna)*
1973/1996
oil on panel
32 × 26 cm
Private collection, New Brunswick
Illustrated: p. 107

March Night
1976
oil on hardboard
101.6 × 228.6 cm
Art Gallery of Ontario, Toronto.
Purchased with assistance from
Wintario, 1977
Illustrated: pp. 14–15

Gulf of St. Lawrence
1976–84
oil on hardboard
71 × 71 cm
Imperial Oil Limited
Illustrated: p. 9

The Visitor
1977
oil on hardboard
94.6 × 226.8 cm triptych
National Gallery of Canada, Ottawa
Illustrated: pp. 64–65

Basement Flat
1978
oil on hardboard
106.7 × 106.7 cm
Musée d'art contemporain de Montréal,
Lavalin Collection
Illustrated: p. 17

*Study for "Hawke Harbour" ("Whaling
Station")*
1978
pencil on paper
7.9 × 27.6 cm
Vancouver Art Gallery. Gift of the artist
Illustrated: p. 53

Exit
1978–79
oil on hardboard
132.1 × 81.3 cm
Private collection, United Kingdom
Illustrated: p. 105

Dresser and Dark Window
1981
oil on hardboard
92.7 × 106.7 cm
Vancouver Art Gallery. Gift of J. Ron
Longstaffe
Illustrated: p. 96

Flashlight
1982
oil on hardboard
81.4 × 96.5 cm
Collection of Joan Carlisle-Irving
Illustrated: p. 2

Whaling Station
1983
oil on hardboard
101.6 × 228.6 cm
Vancouver Art Gallery. Gift of Dr. and
Mrs. N.B. Keevil
Illustrated: pp. 18–19

Girl in the Spare Room
1984
oil on hardboard
69.9 × 92.7 cm
Montreal Museum of Fine Arts. Gift
of Reginald S. Bennett
Illustrated: pp. 46–47

Pink Sink
1984
oil on hardboard
177.8 × 76.2 cm
Vancouver Art Gallery, Joan Callahan
Fund and Vancouver Art Gallery
Acquisition Fund
Illustrated: p. 96

Blue Dianne
1984/1996
oil on panel
33 × 25 cm
Collection of Mira Godard
Illustrated: p. 106

Big Boat
1986–87
oil on canvas
124.5 × 292.7 cm
Art Gallery of Nova Scotia, Halifax
Illustrated: pp. 22–23

Curved Corridor
1987
graphite on paper
11.5 × 20.7 cm
The Rooms Corporation, Provincial Art
Gallery Division, St. John's, Memorial
University of Newfoundland Collection

Curved Corridor
1987
graphite on paper
17 × 31.5 cm
The Rooms Corporation, Provincial Art
Gallery Division, St. John's, Memorial
University of Newfoundland Collection

Curved Corridor, Airport Flight
1987
graphite on paper
11.4 × 20.7 cm
The Rooms Corporation, Provincial Art
Gallery Division, St. John's, Memorial
University of Newfoundland Collection

Going Away (Curved Corridor)
1987
graphite on paper
6 × 11.8 cm
The Rooms Corporation, Provincial Art
Gallery Division, St. John's, Memorial
University of Newfoundland Collection
Illustrated: p. 42

Study for "Curved Corridor"
1987
graphite on tracing paper and graphite
on paper
17 × 31.5 cm
The Rooms Corporation, Provincial Art
Gallery Division, St. John's, Memorial
University of Newfoundland Collection

Untitled (Curved Corridor)
1987
graphite on tracing paper
17 × 31.5 cm
The Rooms Corporation, Provincial Art
Gallery Division, St. John's, Memorial
University of Newfoundland Collection
Illustrated: p. 42

Night Road
1988
oil on canvas
101.6 × 152.4 cm
Collection of Jack and Harriet Lazare,
Montreal
Illustrated: pp. 28–29

Salt Shed Interior
1988
oil on canvas
137.2 × 264.2 cm
Private collection
Illustrated: p. 27

Tower, Light and Tanker
1988
oil on hardboard
95.3 × 109.2 cm
Collection of Mira Godard
Illustrated: p. 103

Irish Point
1989
oil on canvas
104.1 × 137.2 cm
RBC Financial Group
Illustrated: p. 59

The Island
1989
oil on canvas
101.6 × 228.6 cm
Imperial Oil Limited
Illustrated: p. 24

**Perspective Study for "Pedestrian
Tunnel"**
1989
graphite on paper
17.1 × 31.4 cm
The Rooms Corporation, Provincial Art
Gallery Division, St. John's, Memorial
University of Newfoundland Collection,
J.K. Pratt Memorial Collection
Illustrated: p. 42

Black Pickup
1990
oil on hardboard
86.7 × 101.9 cm
Collection of Jane and Raphael
Bernstein
Illustrated: p. 69

In the Heat of Summer
1990
oil on hardboard
101.6 × 228.6 cm
Imperial Oil Limited
Illustrated: p. 25

Pedestrian Tunnel
1991
oil on canvas
102.9 × 190.5 cm
London Life Insurance Company
Illustrated: p. 42

A Room at St. Vincent's
1992
oil on canvas
106.7 × 121.9 cm
Collection of Dr. Michael E. Gardner
Illustrated: p. 58

Big Cigarette
1993
oil on canvas
77.2 × 132.7 cm
Beaverbrook Art Gallery, Fredericton,
N.B. Gift of Harrison McCain
Illustrated: p. 21

Freight Shed
1993
oil on canvas
96.5 × 152.4 cm
Private collection
Illustrated: p. 102

Moose and Transports
1993
oil on canvas
83.8 × 114.3 cm
Collection of Jane and Raphael
Bernstein
Illustrated: p. 90

Basement with Two Beds
1995
oil on hardboard
88.9 × 101.6 cm
Private collection, Canada
Illustrated: p. 63

Ferry Terminal
1995
oil on canvas
76.2 × 152.5 cm
UBS Securities Canada Inc.
Illustrated: p. 31

My Rooms
1995
oil on canvas
106.7 × 214 cm
Power Corporation of Canada
Illustrated: pp. 98–99

White-Out at Witless Bay Overpass
1996
oil on canvas
106.7 × 213.4 cm
Private collection
Illustrated: pp. 32–33

Witless Bay Overpass
1996
oil on canvas
182.9 × 91.4 cm
Collection of J. Rosenthal
Illustrated: p. 68

Argentia Bunker, August 1989
1997
oil on canvas
81.3 × 152.4 cm
Private collection
Illustrated: p. 54

Jack's Dream of Summer
1997
oil on hardboard
63.8 × 138.7 cm
Collection of David Marshall
Illustrated: p. 30

Benoit's Cove: Sheds in Winter
1998
oil on hardboard
68.6 × 152.4 cm
The Rooms Corporation, Provincial Art
Gallery Division, St. John's, Memorial
University of Newfoundland (Art Gallery
of Newfoundland and Labrador)
Collection. Acquired through The
Canada Council for the Arts
Acquisitions Assistance Program and
the generous support of an anonymous
donor
Illustrated: p. 83

Ferolle Point Light
1998
oil on canvas
101.6 × 127 cm
Collection of Donald R. Sobey
Illustrated: p. 84

**Self-Portrait: Who Is This Sir
Munnings?**
1998
mixed media
91 × 162.5 cm
RBC Financial Group
Illustrated: p. 35

Three Windows: Study for "Deer Lake"
1998
mixed media on paper
34.3 × 46.7 cm
Collection of Clifford E. Atkinson
Illustrated: p. 78

**The West Windows: Study for "Deer
Lake"**
1998
mixed media on paper
54 × 73.7 cm
Collection of Philip R.L. Somerville,
Ottawa
Illustrated: p. 78

Window at Deer Lake
1998
mixed media on paper
53.3 × 37. 5 cm
Private collection
Illustrated: p. 78

The Americans: Off-Base Housing
1999
oil on canvas
71.1 × 172.7 cm
Collection of Ron Joyce
Illustrated: p. 56–57

Deer Lake: Junction Brook Memorial
1999
oil on canvas
114.5 × 305 cm
National Gallery of Canada, Ottawa.
Gift of David and Margaret Marshall,
Toronto, 1999
Illustrated: pp. 80–81

Driving to Venus (preliminary sketch book page)
1999
pencil on paper
21.5 × 16.4 cm
The Rooms Corporation, Provincial Art Gallery Division, St. John's, Emily Christina Dawe Collection

Military Presence
1999
oil on canvas
121.9 × 142.2 cm
Collection of Margaret L. Marshall
Illustrated: p. 55

Driving to Venus: From Eddies Cove East (working study)
2000
pencil on technical paper
56.4 × 85.8 cm
The Rooms Corporation, Provincial Art Gallery Division, St. John's, Emily Christina Dawe Collection
Illustrated: p. 75

Study for "Driving to Venus"
2000
pencil on technical paper
21.5 × 27.8 cm
The Rooms Corporation, Provincial Art Gallery Division, St. John's, Emily Christina Dawe Collection
Illustrated: p. 75

Study for "Driving to Venus"
2000
pencil on technical paper
21.5 × 27.8 cm
The Rooms Corporation, Provincial Art Gallery Division, St. John's, Emily Christina Dawe Collection
Illustrated: p. 75

Study for "Driving to Venus" (preliminary study 10)
2000
pencil on technical paper
28 × 43.2 cm
The Rooms Corporation, Provincial Art Gallery Division, St. John's, Emily Christina Dawe Collection
Illustrated: p. 75

Driving to Venus: From Eddies Cove East
2000
oil on hardboard
101.6 × 165.1 cm
Shaw Communications Inc.
Illustrated: pp. 70–71, cover

Driving to Venus: On the Burgeo Road
2000
oil on hardboard
101.6 × 165.1 cm
Private collection
Illustrated: pp. 72–73

Driving to Venus: A Long and Winding Road (study)
2001
pencil on technical paper
20.6 × 27.8 cm
The Rooms Corporation, Provincial Art Gallery Division, St. John's, Emily Christina Dawe Collection

Driving to Venus: A Long and Winding Road (study)
2001
pencil on technical paper
21.7 × 28 cm
The Rooms Corporation, Provincial Art Gallery Division, St. John's, Emily Christina Dawe Collection

Driving to Venus: A Long and Winding Road
2001
oil on canvas
152.4 × 177.8 cm
Private collection
Illustrated: p. 74

A Blizzard at Boswarlos
2001
oil on canvas
127 × 147.3 cm
Collection of Eva Seidner and Michael Kedar
Illustrated: p. 85

Half Moon and Bright Stars: My Bedroom in September
2001
oil on canvas
127 × 203.2 cm
Collection of David Marshall
Illustrated: p. 67

Railcar Camper Twilight at Peter Stride's Lake
2001
oil on hardboard
81.3 × 203.2 cm
Shaw Communications Inc.
Illustrated: p. 82

Crab Plant with Cat Tracks
2002
oil on canvas
152.4 × 152.4 cm
Private collection, Toronto
Illustrated: p. 101

Snow Fence and Mars
2002
oil on canvas
121.9 × 142.2 cm
Private collection
Illustrated: p. 109

Storm on My Porch
2002
oil on canvas
152.4 × 142.2 cm
Collection of Jim and Sylvia McGovern
Illustrated: p. 60

Suburbs Standing West
2002
oil on canvas
96.5 × 157.5 cm
Owens Art Gallery, Sackville, N.B. Purchased with funds from the Friends of the Owens Art Gallery and the Ruth Lockhart Eisenhauer Art Fund
Illustrated: p. 76

Bear Cove, on the Strait of Belle Isle
2003
oil on canvas
101.6 × 165.1 cm
Collection of the Rogan Foundation
Illustrated: p. 86

East Bay, Port au Port Bay
2003
oil on hardboard
81.3 × 142.2 cm
Private collection
Illustrated: p. 87

Four White Boats: Canadian Gothic
2003
oil on hardboard
92 × 204.5 cm
Collection of Carolyn and Pierre G. Gagnon
Illustrated: p. 49

Study (Sunset), "Winter at Whiteway"
2003
pencil on paper
27.6 × 45.7 cm
Collection of Mr. W.J. Wyatt
Illustrated: p. 88

Study, "Winter at Whiteway"
2003
pencil on paper
21.6 × 27.9 cm
Collection of Mr. W.J. Wyatt
Illustrated: p. 88

Study #1, "Winter at Whiteway"
2003
pencil on paper
27.6 × 45.7 cm
Collection of Mr. W.J. Wyatt
Illustrated: p. 88

Study #2, "Winter at Whiteway"
2003
pencil on paper
27.6 × 45.7 cm
Collection of Mr. W.J. Wyatt
Illustrated: p. 88

Study #3, "Winter at Whiteway"
2003
pencil on paper
27.6 × 45.7 cm
Collection of Mr. W.J. Wyatt
Illustrated: p. 88

Winter at Whiteway
2004
oil on canvas
203.2 × 203.2 cm
Collection of Mr. W.J. Wyatt
Illustrated: p. 37

Published in conjunction with the exhibition *Christopher Pratt*, organized and circulated by the National Gallery of Canada, Ottawa.

Tour itinerary

National Gallery of Canada, Ottawa
30 September 2005–8 January 2006

Art Gallery of Nova Scotia, Halifax
3 February–7 May 2006

The Rooms, Provincial Art Gallery Division, St. John's, Newfoundland and Labrador
2 June–4 September 2006

The Winnipeg Art Gallery
4 October 2006–7 January 2007

National Gallery of Canada
380 Sussex Drive, P.O. Box 427, Station A
Ottawa, Ontario
Canada K1N 9N4
www.national.gallery.ca

Douglas & McIntyre Ltd.
2323 Quebec Street, Suite 201
Vancouver, British Columbia
Canada V5T 4S7
www.douglas-mcintyre.com

Library and Archives Canada Cataloguing in Publication

Pratt, Christopher, 1935–

Christopher Pratt: all my own work / Josée Drouin-Brisebois; with an introduction by Jeffrey Spalding.

Catalogue of an exhibition held at the National Gallery of Canada, Sept. 30, 2005–Jan. 8, 2006 and travelling to other galleries.

Also issued in French under the title: Christopher Pratt : de ma propre main.

Includes bibliographical references.

ISBN-13: 978-1-55365-145-1
ISBN-10: 1-55365-145-6

1. Pratt, Christopher, 1935– –Exhibitions. 2. Newfoundland and Labrador in art– Exhibitions. I. Drouin-Brisebois, Josée, 1972– II. Spalding, Jeffrey, 1951– III. National Gallery of Canada IV. Title. V. Title: All my own work.

ND249.P7A4 2005 759.11 C2005-904308-3

Produced by the Publications Division of the National Gallery of Canada, Ottawa, in association with Douglas & McIntyre, Vancouver/Toronto.
Chief of Publications: Serge Thériault
Editors: Marnie Butvin, Stéphanie Moreau, and Danielle Martel
Translators: Julie Desgagné, Arlette Francière, and Traductions Larrass Translations
Picture Editor: Andrea Fajrajsl
Coordinator: Anne Tessier

Jacket and text design by Fugazi, Montreal
Front jacket: *Driving to Venus: From Eddies Cove East*, 2000
Printed and bound in Canada by Friesens
Printed on acid-free paper

Douglas & McIntyre gratefully acknowledges the financial support of the Canada Council for the Arts, the British Columbia Arts Council, and the Government of Canada through the Book Publishing Industry Development Program (BPIDP) for its publishing activities.

Photograph Credits

Art Gallery of Ontario/Carlo Catenazzi: 14–15
Confederation Centre of the Arts: 13
Courtesy of the artist: 61
Peter D'Angelo: 116 (bottom)
Shirley Greer: 119 (bottom)
Christine Guest, Montreal Museum of Fine Arts: 46–47
Jim Jardine, Vancouver Art Gallery: 18–19
Jeanette Meehan: 120 (bottom), 121 (top)
Trevor Mills, Vancouver Art Gallery: 96 (left)
Mira Godard Gallery, Toronto: cover, 4, 9, 21–24, 26 (left), 27–33, 35, 37, 42 (bottom), 54, 56–57, 59, 63, 66–74, 76, 78 (left), 80–85, 90, 101–03, 105–06, 109
Thomas Moore, Toronto: 25, 55, 58, 62, 88
Musée d'art contemporain de Montréal: 57 (right)
National Gallery of Canada, Ottawa: 10–11, 44 (left), 45, 48–49, 51, 60, 64–65, 78 (right), 80–81, 86–87, 95, 98–99, 107
Ned Pratt, St. John's: 26 (right), 42 (top), 44 (right), 75, 121 (middle, bottom)
John Reeves: 115 (top), 119 (top)
Steven Sloman © 1988: 93
Tomas Svab, Vancouver Art Gallery: 53, 96 (right)
Richard-Max Tremblay, Musée d'art contemporain de Montréal: 17
Jürgen Vogt: 118 (bottom)